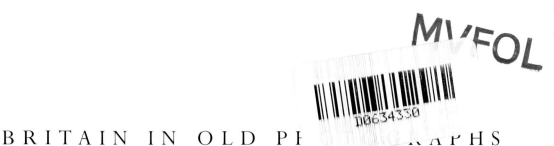

BRITAIN IN OLD PHOTOGRAPHS

STOCKTON-ON-TEES

CHARLIE EMETT

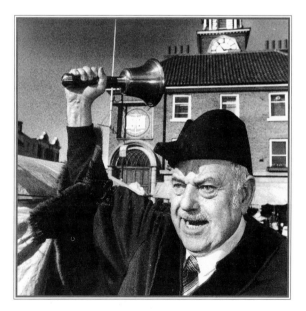

SUTTON PUBLISHING LIMITED

Sutton Publishing Limited
Phoenix Mill · Thrupp · Stroud
Gloucestershire · GL5 2BU

First published 1998

Copyright © Charlie Emett, 1998

Title page: Tom Sowler, bellringer for
Stockton's bank holiday market, outside the
town hall.

British Library Cataloguing in Publication Data
A catalogue record for this book is available from the
British Library.

ISBN 0-7509-1963-9

Typeset in 10/12 Perpetua.
Typesetting and origination by
Sutton Publishing Limited.
Printed in Great Britain by
Ebenezer Baylis, Worcester.

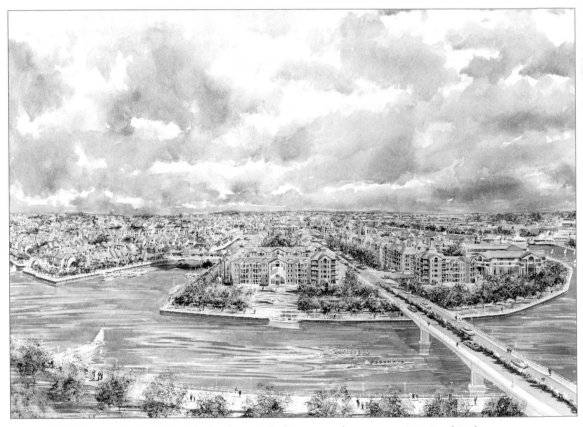

Artist's impression of the Teesdale development looking across the new River Tees Road Bridge.

CONTENTS

ACKNOWLEDGEMENTS

Rummaging around the *Northern Echo* picture library is always a joy, so my special thanks to Andrew Smith, editor of this excellent newspaper, for allowing me to do so. Special thanks, also, to Jane Whitfield, guardian of the *Echo* archives, who is not only beautiful but beautifully competent, and to Jenny Needham and Andrea Lambell, lovely ladies with gleaming smiles who light up Features. Thanks also to Rachel Mason of The Green Dragon Museum, Stockton, and Joyce Chesney of Stockton Reference Library for your valued help and to Ellen Rutter for converting my scrawl into something legible. To Tony Hillman, probably the greatest authority on the silver screen in the north-east, my sincere gratitude for your enthusiasm and practical help; and for your assistance, freely given, I thank you, David Peel, editor, Radio Cleveland. Simon Fletcher and Anne Bennett and your brilliant team at Sutton Publishing: you are wonderful people and working with you is a real pleasure. In such company, I am thrice blessed!

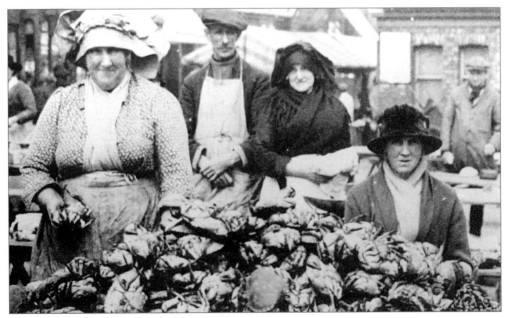

Women selling crabs at Stockton Market, *c.* 1920.

INTRODUCTION

Following the end of Roman rule in the north of England, several small groups of Anglo-Saxons settled close to the Tees. Some established the then pagan homestead of Norton, which covered an area of 15 square miles along the river's northern bank.

During the tenth century one of the sons of the Earl of Northumberland gave Norton to the Bishop of Durham as a token of his admiration for the Bishopric's patron saint, Cuthbert. At that time there were several small settlements within the boundaries of Norton and one of these was Stockton.

The earliest reference to Stockton, the 'tun' or 'village' belonging to the 'stoc' or 'monastery' of the Bishop of Durham, is in the Boldon Book of 1183. Then, eleven villeins and six and a half farmers worked the land. Perhaps the half was there only part-time!

From the outset Stockton lived in the shadow of its neighbours – Yarm, Hartlepool and, later, Middlesbrough. This was because Stockton was part of the Palatinate of Durham, a closed economy. It was one of many towns established by the Bishop to supply the needs of his own household and make a profit from the commercial activities of his tenants. Of all the towns in Durham, only Barnard Castle and Hartlepool were lay foundations. Stockton had little independence and its inhabitants were forbidden to trade with the opposite bank of the Tees. The burgesses, however, had a near monopoly of marketing in south-east Durham and freedom from tolls throughout the Palatinate, whose local economy was not geared to long-distance trading relationships in goods like wool, cloth and lead sent to the south of England or overseas. So, while places like Yarm and Hartlepool waxed fat, Stockton failed to attract sea-borne trade simply because it made little attempt to do so.

The manor of Stockton, created in about 1183, was purchased by Bishop Pudsey in 1189. The date at which the manor gained a Charter of Incorporation is not known, but it is thought that the Bishop of Durham made it 'a borough by prescription' in the mid-thirteenth century.

Bishop Bec gave Stockton a market charter in 1310, Bishop Tobias Matthew renewed it in 1602 and then a further market charter was granted by Bishop John Cosin. So the history of Stockton and that of the Bishopric remained closely entwined, until in 1536 the legal authority of the Bishop's Palatinate was greatly reduced by the Jurisdiction of Liberties Act.

The years immediately following the lessening of the Bishopric's power were probably the darkest in Stockton's history. None of the 120 dwellings recorded in the parish register for 1666 were of brick, the population was beginning to fall, its markets and fairs had lapsed and its church only narrowly escaped dissolution as a chantry. It was all part of a national decline of urban life with more of the nation's trade becoming concentrated in London; and Stockton's neighbours, Hartlepool and Yarm, fared worse than it did. Only one or two ships

visited the Tees each summer and cloth manufacture, that most basic of urban industries, moved to new locations alongside fast-flowing streams; rural areas like the West Riding of Yorkshire were developing large-scale industry. The Industrial Revolution had arrived.

With London booming, the demand for food for its rapidly expanding population became insatiable. Responding to it, the rich dairying farmlands of the Vale of York, the Cleveland Plain and the lower Dales were producing butter in such large quantities by the 1670s that the ports of the Tees and the North Yorkshire coast acquired a near monopoly of its supply to the London markets.

The Port of Stockton, which included Yarm, became the most important commercial centre between the Humber and the Tyne, a position it held for the next 200 years. Return cargoes, like sugar, tobacco, rum, tea and coffee, which originated in the tropical colonies, enhanced trade and stimulated ship-building. The rich coal trade between Newcastle and London was ever expanding and Stockton supplied the bulk-carriers for it. This entailed importing timber, hemp and iron from Scandinavia and the Baltic.

Against this background, between the mid-seventeenth and mid-eighteenth centuries, Stockton and Yarm developed simultaneously and to roughly the same degree. Both were largely rebuilt and adorned with public buildings. By 1750 both were thriving Hanoverian townships and the future looked good.

By the early nineteenth century Stockton's future lay in the hands of its merchants and craftsmen; enterprising people who continually promoted and financed many enterprising schemes. They were an integral part of the town's unique social and economic structure, which stemmed from the early development of the share principle in shipping: this had become popular because of the financial risk involved. Upwards of thirty people might own one ship, so investment was spread across the whole community, not concentrated among a few large capitalists. Thus a great many people were involved in Stockton's general prosperity as well as their own businesses.

In 1810, following calls for an improved local transport system, proposals for either a canal or railway to link Stockton to the south Durham coalfields were made. The canal scheme was dropped, being too expensive, but a railway line from Stockton to Witton Park Colliery was authorised by an Act of Parliament on 19 April 1821. The Act was passed largely because shareholding at Stockton was spread across all the commercial community.

Although some iron works were established in Stockton, Middlesbrough was the iron town. Stockton's industrial base was more diversified: foundry work, marine and locomotive engineering, ship-building. Stockton remained a regional market town with a large professional and commercial middle-class population.

By the early years of the twentieth century living conditions in Stockton had deteriorated to such an extent that a slum clearance programme was initiated during the 1920s. Then came the Depression: shipyards and engineering works closed and Stockton's dark days continued.

Today a revitalised Stockton, which once backed on to the Tees, now turns its front to it. New housing and shopping centres and a modern road system have replaced the slums, and Stocktonians enthuse about Stockton's 'miracle', the £50m Tees Barrage, which is making the town so attractive to industrialists, businesspeople and sportsmen and women alike. With it, enterprising Teesside Development Corporation has produced a model others are eager to follow, and given Stockton the means to stride confidently into the twenty-first century.

THE BISHOPRIC CONNECTION

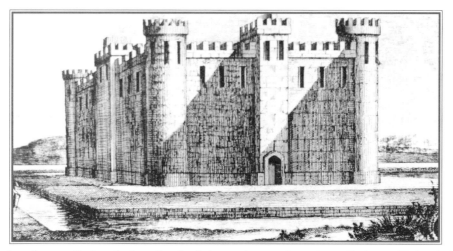

The first reference to Stockton Castle, really a fortified manor house similar to those at Durham and Bishop Auckland, but less elaborate, is in the Boldon Book, a survey published by Bishop Puiset in 1183. It was an impressive structure with a moat and earthworks, but with little military significance, being a place for entertaining guests and an occasional residence. King John stayed there in 1246 and marauding Scots plundered it and set it on fire in 1322. The damage was made good and later, under Bishop Langley, in the first half of the fifteenth century, further buildings were added. There is doubt about whether or not Stockton Castle was occupied during that confused rebellion, the Pilgrimage of Grace, when insurgent priests attempted to reinstate the religious houses and re-establish the 'old faith' in the north. Bishop Tunstall lived there then and Henry VIII was suspicious of the man's involvement with the rising. Ominously for the Bishopric, in 1537 an Act for the abolition of the Palatinate was passed. Although the Bishop was stripped of all his greatest Palatinate honours, his possessions were not affected. But in 1543 Stockton Castle was garrisoned by Henry's men. On 29 August 1640 Bishop Morton fled from Durham and took refuge from an advancing Covenanting Army in Stockton Castle, then garrisoned by the forces of Charles I. In 1644, after the Royalist defeat at Marston Moor, Scottish forces took Stockton and stayed there until 1647, when it was resolved in Parliament 'that Stockton Castle be made untenable and the garrison disgarrisoned'. That year Stockton Castle was sold to William Underwood and James Nelthorpe for £6,165 10s 2½d. Most of it was demolished, the stones being re-used elsewhere. A barn remained. It was converted into two castellated cowsheds, which were pulled down in 1865.

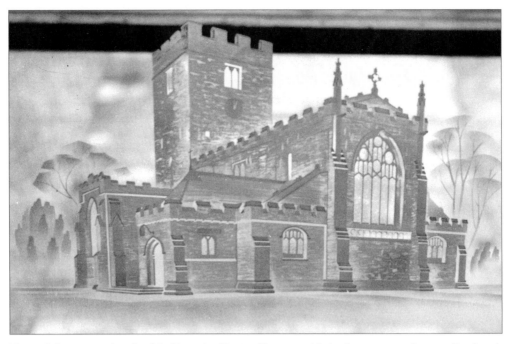

The eighth-century church of St Mary the Virgin, Norton, with its Saxon tower, became Stockton's mother church during the Middle Ages.

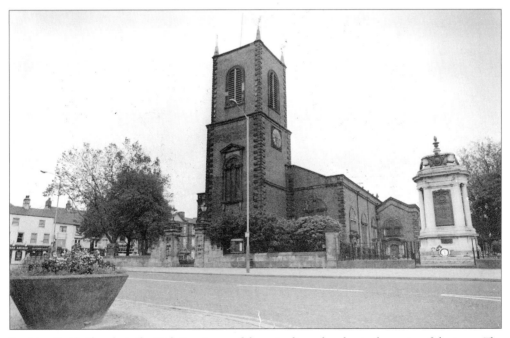

Stockton Parish Church, in the High Street, one of three Anglican churches in the centre of the town. The other two were Holy Trinity in Yarm Lane, and St John's in Alma Street, near the gasworks. Sited at the northern end of High Street, Stockton Parish Church, a replacement for a chapel of ease, took two years to build. Work began in 1710 and the church was consecrated on 21 August 1712. The chancel was rebuilt in 1906 and a side chapel was added in 1925. The war memorial was built in 1923.

Holy Trinity Church, an imposing Gothic-style church with flying buttresses, was built on land provided by Bishop van Mildert, the last of Durham's prince bishops. It is thought that Holy Trinity was a 'Waterloo Church', one of several built by a grateful government to commemorate the victory at Waterloo on 18 June 1815. The church was consecrated on 22 December 1838. After the Second World War, largely because of population movements, congregations shrank and the church was closed.

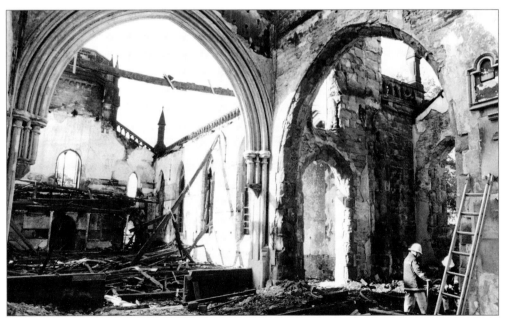

Following its closure as a Church of England place of worship, the Greek Orthodox community used Holy Trinity Church until October 1991, when a devilish fire gutted the interior and put a large question mark over the building's future.

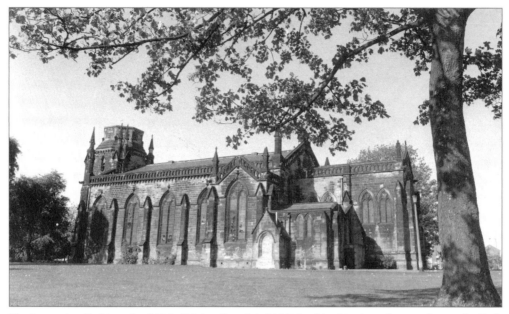

The impressive Gothic style of Holy Trinity Church is highlighted in this view of its northern side. Built on land granted by the Bishop of Durham in 1832, Holy Trinity Church was opened in 1838.

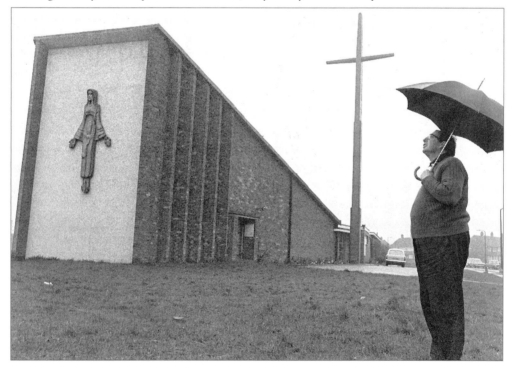

The modern design of St James's Church contrasts sharply with the Gothic splendour of Holy Trinity. The bronze fibreglass figure of Christ is 15 ft long and dominates one of the biggest housing estates in Stockton. The reinforced concrete cross is 67 ft high. When it was erected Mr Eric Sauvary, the site foreman, who hails from the Channel Islands, put a Guernsey silver threepenny bit on top of it for good luck. The church was built during the 1960s to serve the new estate.

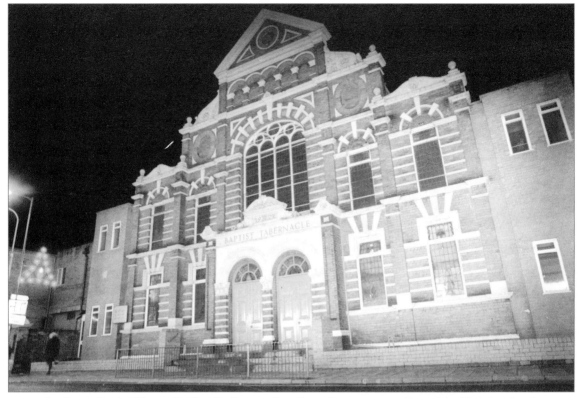

Stockton's Baptist Tabernacle Church. From earliest times there were members of the Christian church who opposed infant baptism and held the view that only those who were in fact believers should be baptised. This view gained currency all over Europe and in 1609 a church of baptised believers was established in Amsterdam among a group of exiles from England. In 1611 the first English Baptist church was opened at Spitalfields, London, by some of those exiles who had returned. In 1639 a Baptist settlement was established in Rhode Island, which laid the American foundation of the movement. The religious revival of 1740–3, known as the Great Awakening, stimulated the growth of the movement in the United States. In England people like John Bunyan, who was a Baptist, suffered for their beliefs until the Act of Toleration of 1689 made life easier for all nonconformists in Britain. On 13 February of that year, William and Mary became joint sovereigns. Their accession opened a new era in English history since they had been made rulers by the representatives of the English upper classes in Parliament. No monarch could now rule without Parliament's agreement. Their accession also brought to an end the religious struggles of the sixteenth and seventeenth centuries. An Act of Parliament of 1689 debarred Catholics from the throne, while the Act of Toleration ended the persecution of nonconformists and gave Catholics tacit freedom to worship. However, it was not until the end of the eighteenth century that the Baptists were active again, when there was a marked revival in the new industrial areas. In 1896 Baptists took a prominent part in the establishment of the National Free Church Council, and in 1905 the Baptist World Alliance was founded to promote unity everywhere. As a result of their insistence on believers' baptism, Baptists found it difficult to accept schemes put forward for union with other Christian bodies.

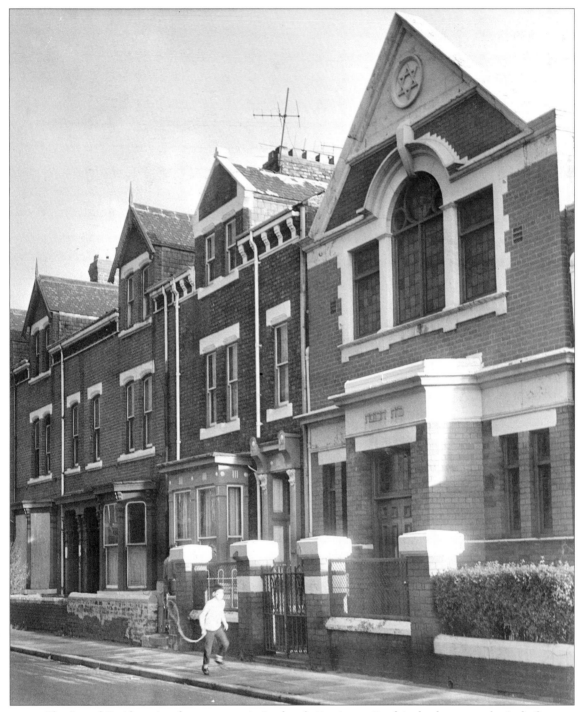

The Star of David gracing the synagogue in Stockton's Hartington Road is also known as the Seal of Solomon, for, according to Sommerhoff (1701) star and seal are one and the same thing. The Seal of Solomon is the graphic origin of the four most common sigils of the four elements, earth, fire, air and water, while the blank space in the middle represents the invisible spirit world. Together these sigils tell of the common bond of Gentile and Jew to the spirit world to which, in time, all of us will be transported.

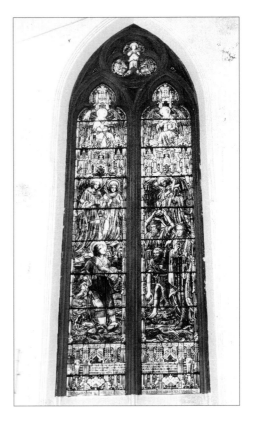

Like the well-known hymn book, these two pictures
are Ancient and Modern. They clearly show the
extent to which modern artists using modern
materials differ from the traditional romanticism of
an earlier age. The stained glass window is in Holy
Trinity Church. The author once had a car with a
stained glass window. A blackbird did it.

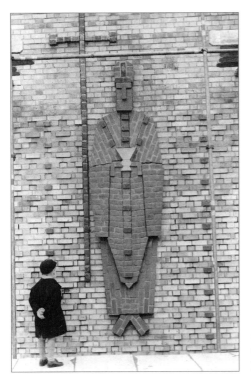

Part of the wall at St Chad's Church, Stockton, with
the figure of St Chad built into it, practising
levitation. Look, no hands!

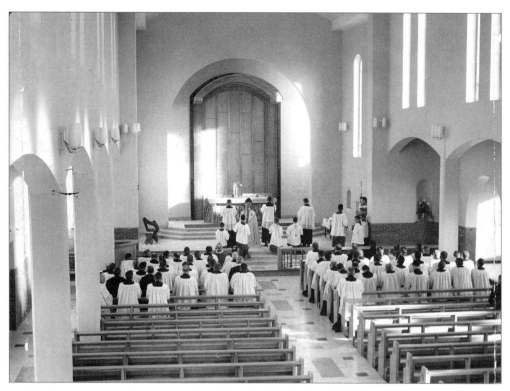

English Martyrs Roman Catholic Church interior following a visit to the surplus stores!

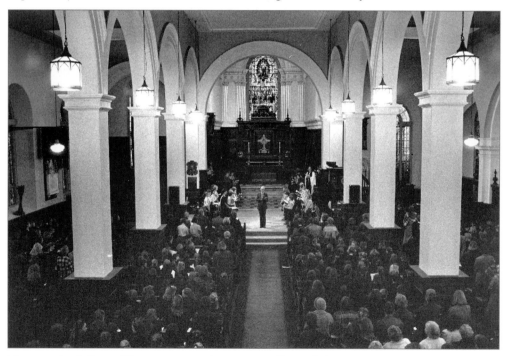

The vicar, Revd Canon Whittington, presiding over a well-attended morning service at Stockton Parish Church.

HIGH STREET

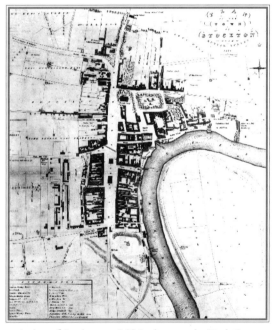

*A plan of Stockton in 1826, showing the High Street
and, at its south end, the site of Stockton Castle.*

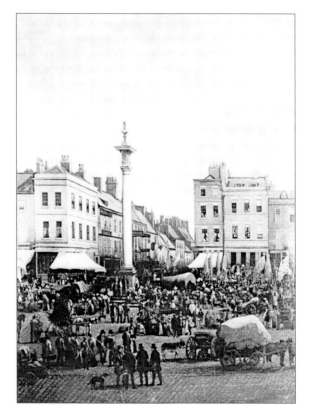

Election Day 1841, showing the Doric Monument and Finkle Street, from a painting dated 1844.

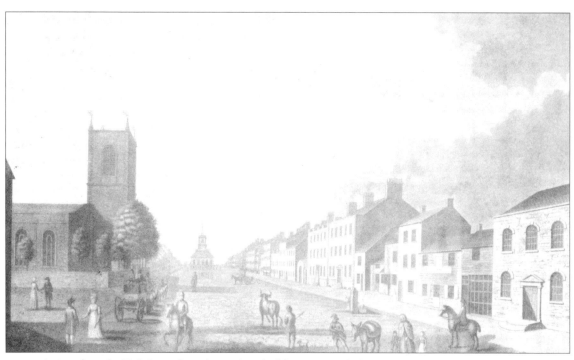

A view along the High Street from the north end of the town, c. 1850.

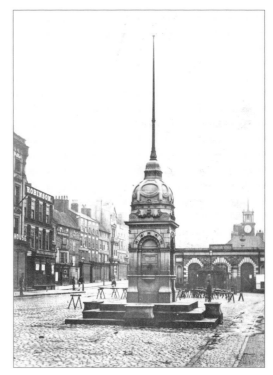

This fountain was erected in the High Street, opposite the Exchange Hall, to the memory of Alderman John Dodshon, President of the local Rechabites, in 1878. Water, for public use, poured from four bronze lions' heads into bowls from where people drank using bronze cups. This memorial also included four horse and four dog troughs. At that time the town's water supply was obtained from wells and springs. Stockton had two pumps, one north of the town hall, the other near the parish church.

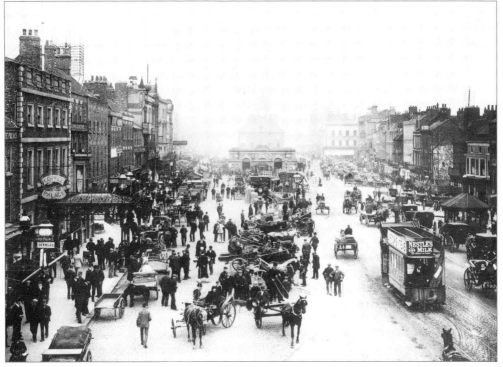

The south end of the High Street, 1890s. Horse-drawn conveyances predominate in this busy scene. The tram has no overhead wires: it is a steam tram and pre-dates the electric-powered variety.

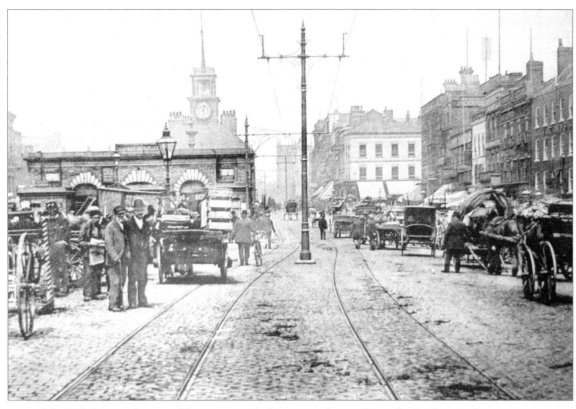

The High Street at the turn of the century with electric tram lines and a market for farm implements.

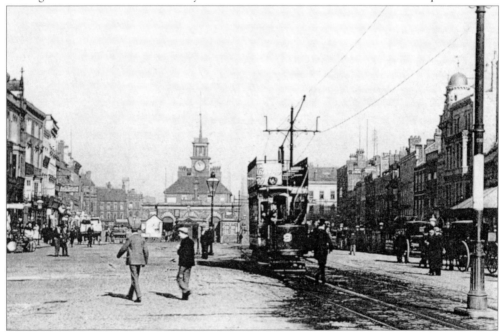

A quiet scene in the High Street, *c.* 1909. Note the horse-drawn taxi carriages on the right. Some idea of the interesting original shops' façades on the east side of the High Street can be seen on the right.

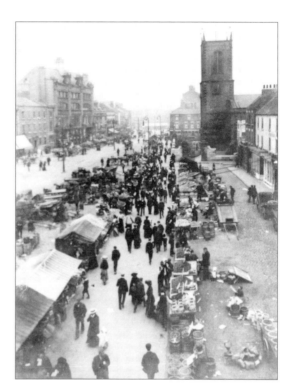

A busy day at Stockton market, 1912. These stalls are close to the clearly seen parish church.

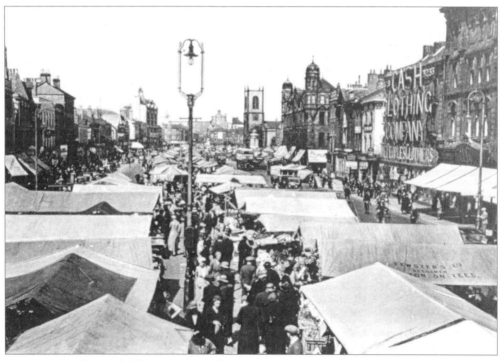

A score of years later and, like Topsy, the market has grown tremendously. Fashions have changed and the High Street has a distinctly commercial look about it. The parish church remains as steadfast as the faith it proclaims.

Cycling down the High Street, 1920s. The Victoria Buildings are on the left. Stockton's first trams, introduced in 1881, were powered by steam. In November 1897 they were replaced by electrically powered trams like the one shown above, which needed overhead power lines. Stockton's trams disappeared in 1931.

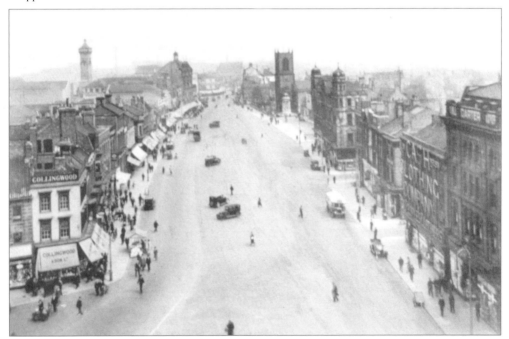

This view of the High Street without its market stalls, c. 1935, shows its vast breadth as it funnels to normal width at its northern end. Pedestrians greatly outnumber vehicles and jaywalk with impunity. Ah, happy days!

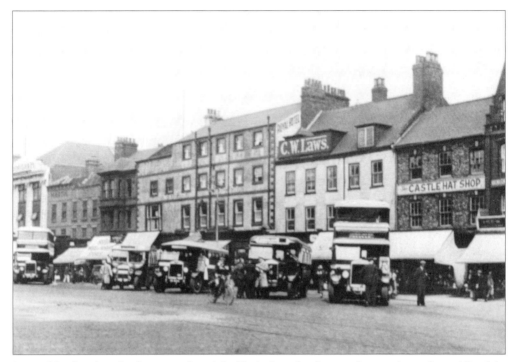

Some of Stockton's earlier buses, single and double deckers, lined up at a bus stand near the middle of the High Street in the inter-war years.

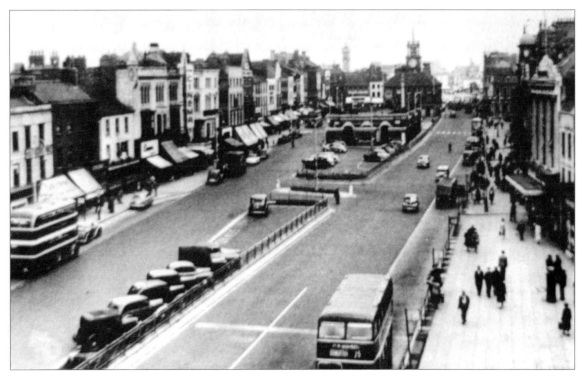

The same bus stand in the 1950s. A line now segregates the buses from other vehicles.

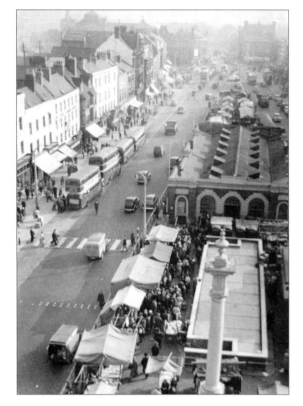

Market Day, 1950s. This is Stockton's
original market, seen from the clock tower
with the Doric Monument in the
foreground.

Typical shop frontages on the High Street,
1966.

Carvings known as Romeo and Juliet on a building in the High Street do not represent Shakespeare's star-crossed lovers. They are no more than an urban myth.

Controversial modern sculpture in the High Street. When it was erected in 1995 many people objected because the engine depicted is Robert Stephenson's *Rocket* not *Locomotion II*, which actually hauled the first train on the Stockton & Darlington Railway.

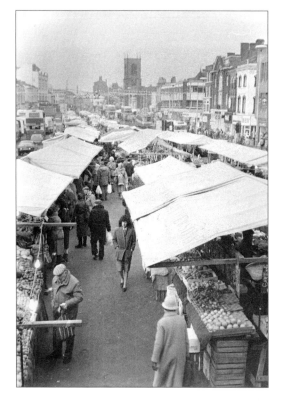

There is a fascination about any huge, long-established open market like this one in the High Street that is missing in the more clinical atmosphere of a superstore. A delicate mix of pungent aromas, the rich, earthy banter of the street traders and the more competitive prices – 'The two for the price of one, missus: you'll not do better' – all combine to bring a tincture of excitement to a normally wearisome chore, family shopping.

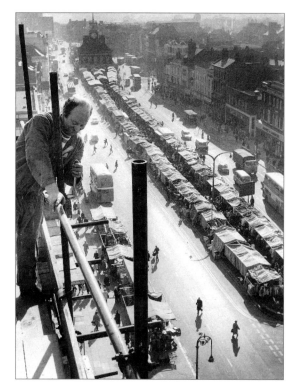

A scaffolder's-eye view of the High Street market on a sunny day in 1973. The two rows of stalls face each other and the shoppers occupy the central space between them.

THE TOWN'S HUB

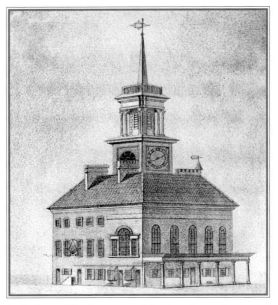

It is not known when the Bishops of Durham granted Stockton borough status. However, Bishop Hugh Pudsey, during the latter half of the twelfth century, was probably the one who endowed its burgesses with power to elect their own mayor and deal with local affairs. At that time the ancient borough was bounded by the River Tees to the east and West Row to the west and from Yarm Lane in the south to Dovecot Street and Silver Street in the north.

Hatfield's Survey of 1382 refers to the mayor's house being for the payment of tolls, market fees and fines. The thatched house also included accommodation for guests during the early part of the seventeenth century and towards the end it became part of a tollbooth, which was probably built of stone from the demolished Stockton Castle. The present town house, the north-east view of which is shown here, was built in 1735 and extended in 1744 to include a second set of chimney-stacks and a clock tower.

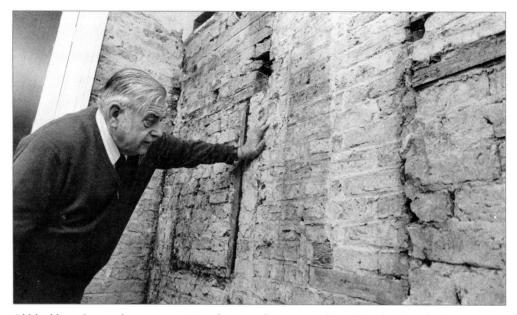

Old buildings frequently expose exciting glimpses of yesteryear. Here historian Tom Sowler examines some rediscovered brickwork at the town hall on 30 June 1984. It is thought that the brickwork is part of dungeons in which prisoners spent their last night before being transported to the colonies. Tom Sowler, Chairman of the 100 Trust, would like this fascinating fact recorded on a memorial plaque.

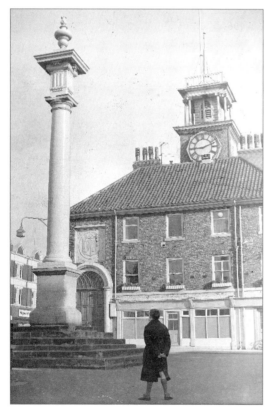

Fronted by the market cross or Doric column, the town hall in 1964 housed an unpopular council, and the general consensus was that Stockton was quickly making a name for itself as a municipal morgue. It was a town, according to some cynics, where laughter needed a licence from a council with a kill-joy record; fairs and circuses – out; holly and Christmas tree sellers – out; colourful market traders – out; requests for money for the arts – out. Oh dear! And these were the kindest observations.

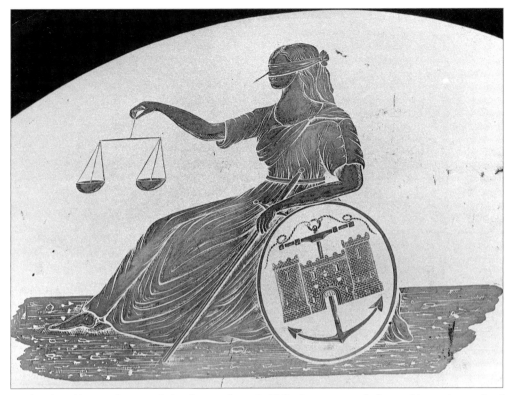

Stockton's emblem on the council chamber windows. In 1964, during a period of council intransigence, local TV personality Luke Casey suggested a new Latin inscription to go under the coat of arms: *Rigor mortis*.

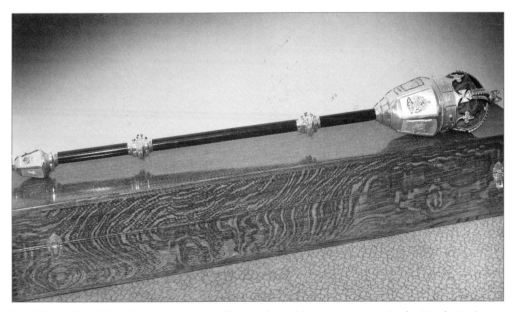

In 1964 the North East Arts Association called Stockton 'the meanest town in the North East'. In a newspaper article, Luke Casey said that when guests are invited to the Mayor's Parlour the most exciting things they can be shown are the mace, the mayoral chain and a copy of the town guide. This is the mace.

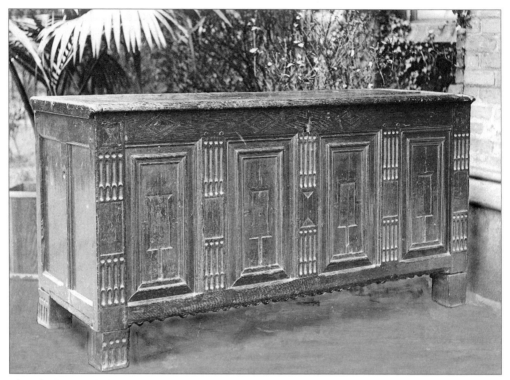

The oak chest in which borough records were kept by the bailiff.

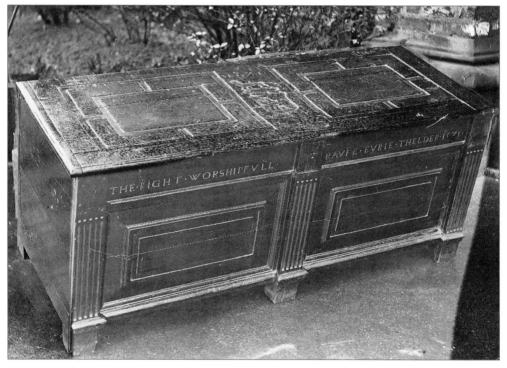

Another oak chest in which borough records were kept. Note the inscription.

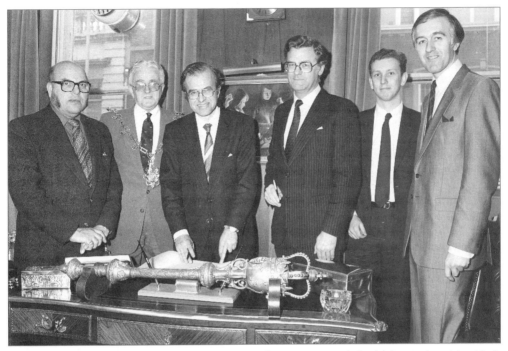

Tempus fugit. Councils change, improvements are made, new men with fresh ideas and exciting ideals usurp earlier councils and Stockton smiles again. These Stockton Borough Council people are with representatives of Hill Samuel, signing a 1984 agreement regarding financial backing to future Stockton Borough Council Developments.

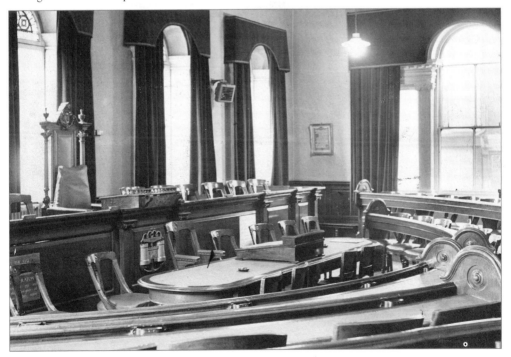

This is Stockton's council chamber with the coat of arms prominent.

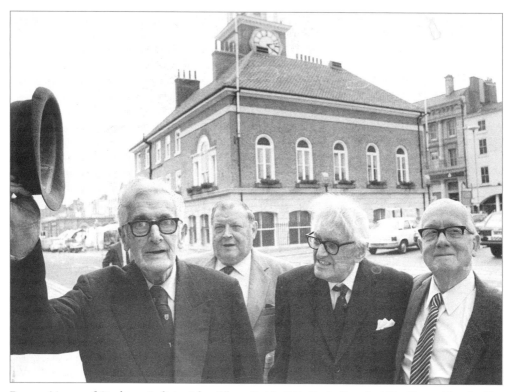

Former Mayors of Stockton. Left to right: Albert Smith (94), Ernie Temple (69), Victor Clough (82), James Darby (77). The picture was taken in 1986. James Darby died in 1991 aged 82.

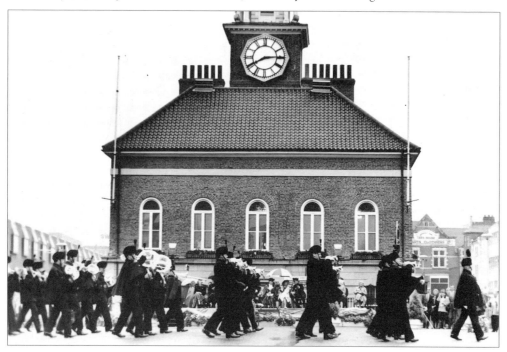

Freedom of the Borough march by the 7th Light Infantry.

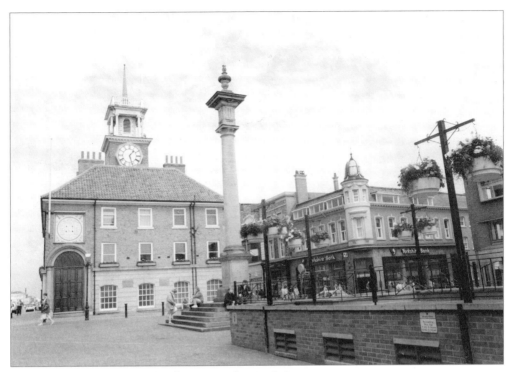

Today's town hall, looking spick and span in its clean High Street setting.

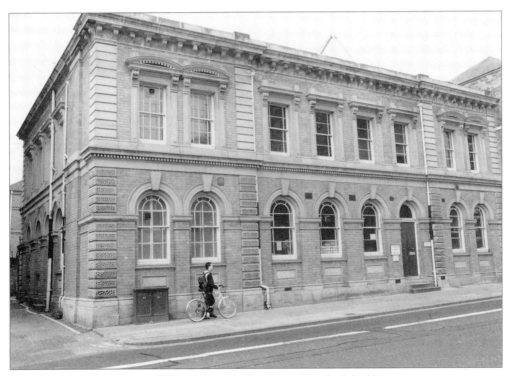

The law courts have been moved from the town hall to this purpose-built building.

This proud lady is as much a credit to Stockton as its council members. Civic-minded Mrs Molly Foulgar, from Stockton, is shown after having won an award for paying her rent on time for many years.

THE URBAN ENVIRONMENT

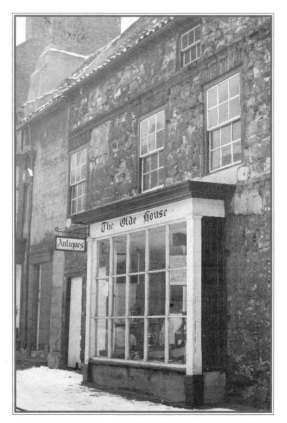

No. 9 Finkle Street, the oldest house in Stockton. No longer an antique shop savouring bygone times, it is now a pram shop catering for the future.

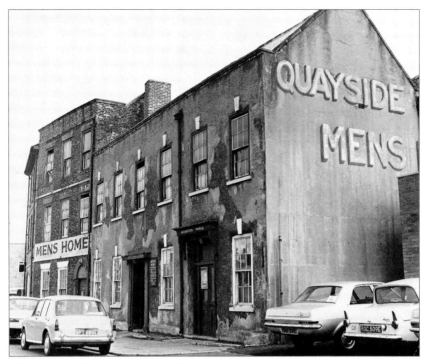

This is not the largest public toilet in Stockton!

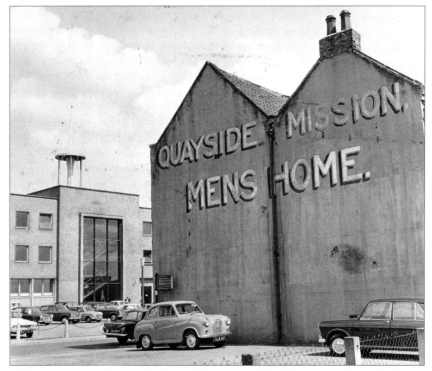

This sad building, overlooked by the splendour of the municipal buildings, is the Quayside Mission, which in 1967, when this picture was taken, was struggling to maintain its desperate day-to-day existence.

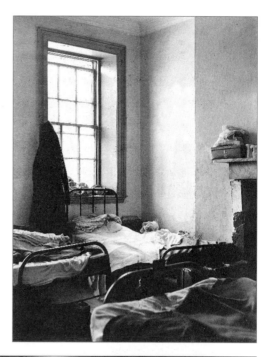

To the sixty destitute men living at the Quayside Mission, its gloomy passages and uncarpeted dormitories were the only home they knew. This corner of a dormitory highlights the squalor. The Quayside Mission, in The Square, Stockton, was housed in a building that had originally been a mansion. It was split into two halves, the mission itself, which regularly attracted good congregations, and cheap, clean, respectable accommodation for workers at the nearby shipyard. It was founded in 1906 and closed in 1973. It has now been demolished.

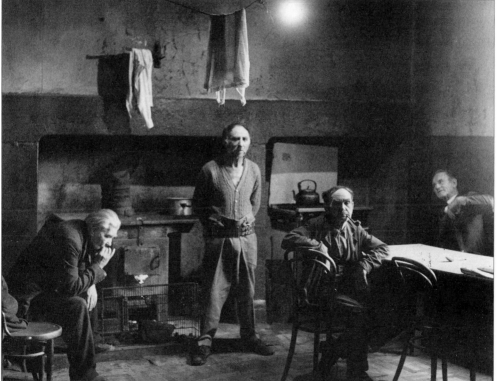

Utter despair is etched on the faces of these wretched residents at the Quayside Mission, where maintenance was difficult when the only guaranteed income was the 25s a week the men paid. For this they were given room and a bed, but provided their own meals.

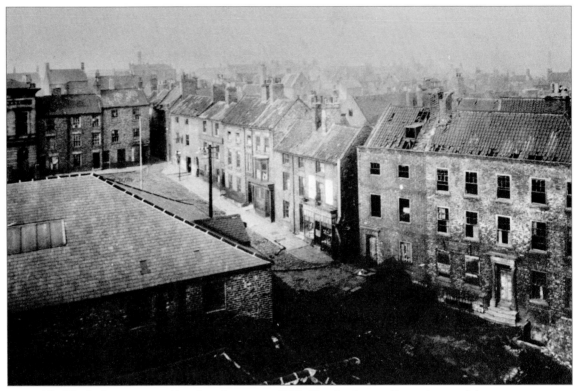

The Thistle Green area awaiting slum clearance, *c.* 1925. Now Stockton police station stands here.

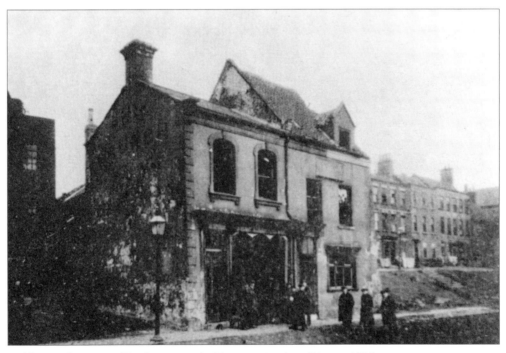

Buildings in the centre of Stockton, near the Tees, awaiting demolition, *c.* 1925.

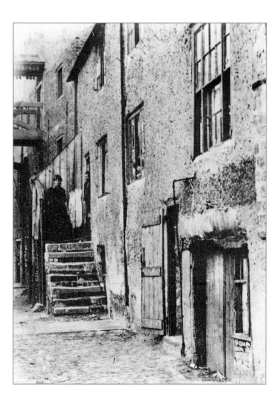

Many mean houses like these were situated behind High Street, access being gained along narrow passages, lanes or yards. This photograph dates from *c*. 1880.

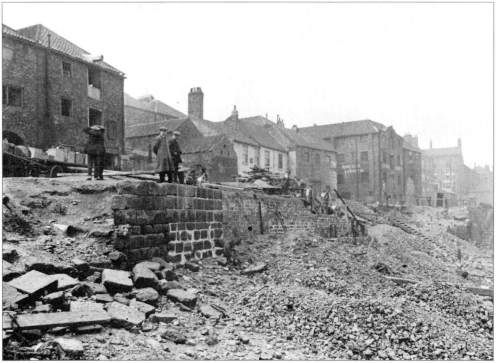

The old order changeth with the century! Riverside buildings near the centre of Stockton bite the dust, *c*. 1900.

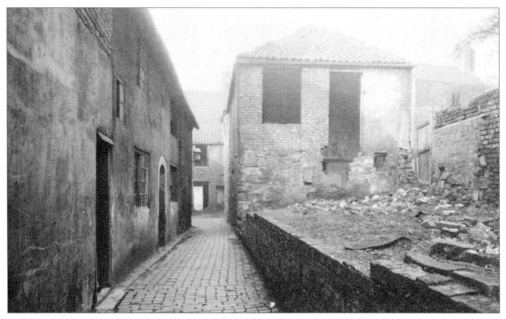

This passage led through the Wasp's Nest to the Georgian Theatre, which was opened in 1766 and 'became dark' during the early 1870s.

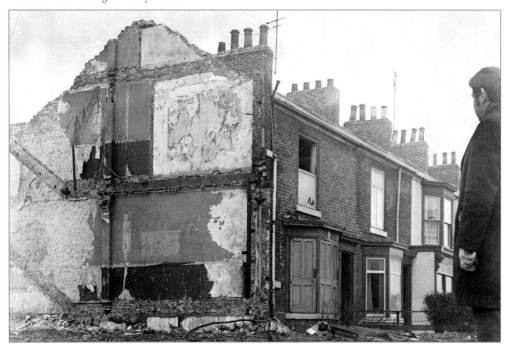

A pair of Georgian houses stood in Norton Road where now only a gap remains. Teesside Civic Society wanted to preserve them and approached Teesside Planning Department, who assured them that the houses could not be pulled down without special permission and that none had been granted. When the *Northern Echo* pointed out that the buildings had already been demolished, red-faced officials examined their most up-to-date plans and pointed out that nos 103 and 105 should still be there. This photograph dates from the mid-1960s.

Stockton's proud High Street hid many scars, but not these derelict houses in Nelson Terrace, which were overlooked from the town's biggest department store. Matthias Robinson's, in the last century Stockton's largest store, was burned down at Christmas 1899. It was rebuilt in 1901. In 1972 it became Debenhams, reopening as such in March of that year. This picture dates from 1972.

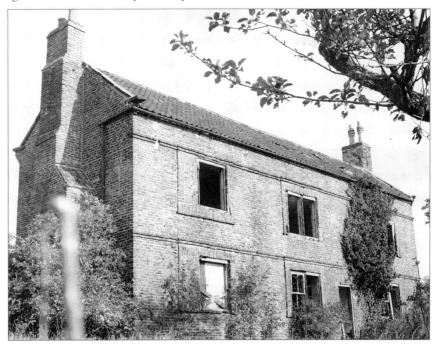

Although it became a Grade II listed building in 1948, having architectural and historical interest, seventeenth-century Stockton Grange Farm has been left to rot, ignored by all the authorities who have owned it, and stands windowless and almost gutted. It was slightly altered in the eighteenth century and boasted a fine staircase, which has now disappeared.

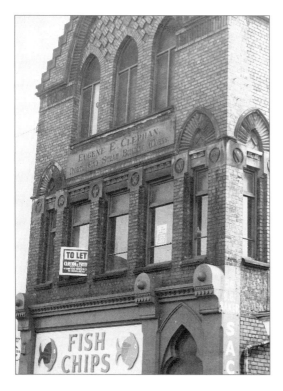

Behind the chiselled name Eugene E. Clephan, which faces Norton Road, lies an interesting story. William Clephan established the North End Steam Building Works business in Stockton. He had two brothers, James and Edwin. William had a son, Eugene, and Edwin had a daughter, Annie Elizabeth, who became a famous artist. She left the Le Tourres painting, *The Dice Players*, to Stockton in her will in 1936. Her bequest also included another painting, *The Fortune Tellers*, reputed to be so valuable that the painting's whereabouts are a closely guarded secret – and it is never shown to the public.

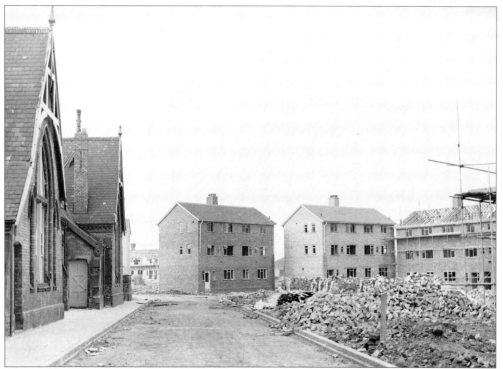

Redevelopment of housing behind Church Street shows the new growing alongside the old, 25 August 1961.

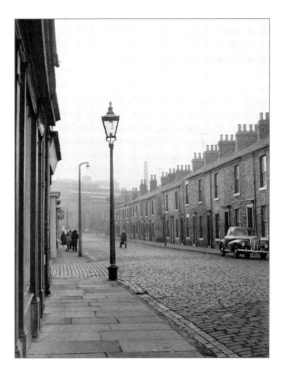

Gradually modern electric street lights usurp the more elegant gas lamps of a gentler age.

In common with other towns, many of Stockton's rows of terraced houses, like Hartington Road, pre-date the car. They have no garage space and road congestion is aggravated.

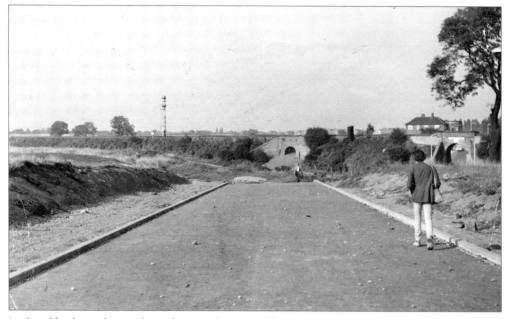

Looking like the road to nowhere, this is an almost complete section of Stockton's new ring road, 1968.

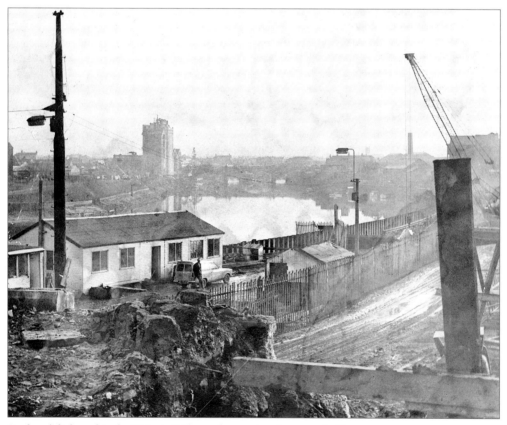

Stockton's link road to the Victoria Bridge under construction over the Tees.

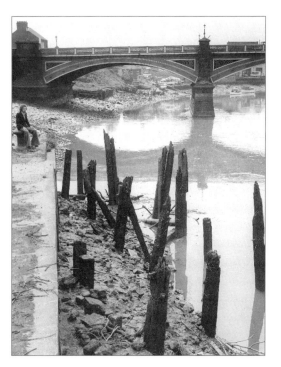

Once a five-arched bridge crossed the Tees at this point. It was replaced by this three-arched one, the Victoria Bridge, named after Queen Victoria, on 20 June 1887.

This former mineral line from Thorpe Thewles to Stockton, used for carrying coal and coke to the Teesside steel furnaces, is now being used by pedestrians as a short cut from Hardwick to Fairfield.

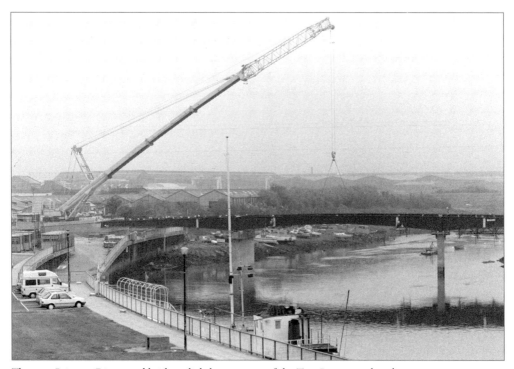

The new Princess Diana road bridge, slightly upstream of the Tees Barrage, takes shape.

The report concerning a canal for Stockton that Robert Whitwell presented to the Committee assembled at the Post House, Darlington, on 24 October 1768, had possibilities, but shortage of cash was always a major stumbling block. A final attempt to finance the scheme was made in 1818. The job could be done for an estimated £225,000. On 31 July that year George Brigham, Land Agent and Surveyor of Windy Hill, Hutton Rudby, produced a list of subscribers to the proposed canal; only £34,500 was raised and the scheme was abandoned. Some of the subscribers are listed here.

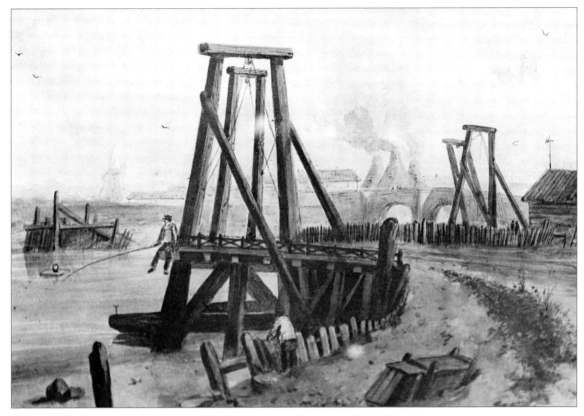

Coal staithes at Stockton. It was from these wharves that coal was loaded into ships.

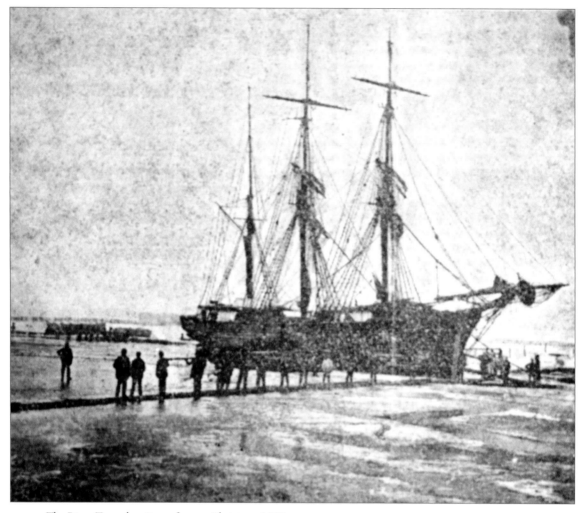

The River Tees when it was frozen, Christmas 1860.

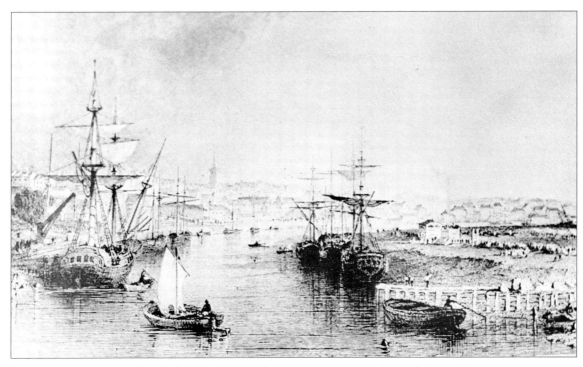

View of Stockton showing the horse-drawn railway coach on the quayside line, left, *c.* 1825.

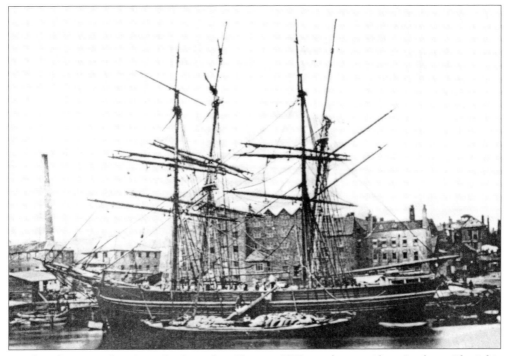

A sailing ship moored at the Bishop's Landing Place, *c.* 1870, on the quayside at Stockton. The Baltic Tavern can be seen beyond the ship's stern. Heavy sacks are being transferred between a small barge and the ship.

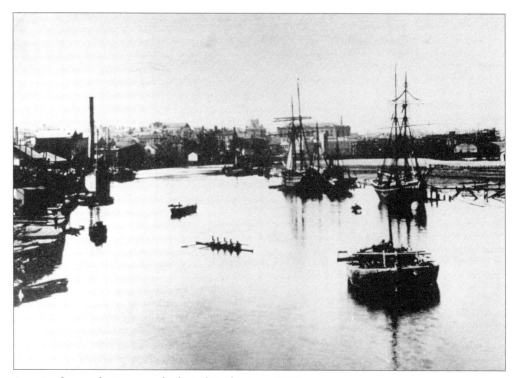

A rowing four on the Tees near the foot of Castlegate, *c*. 1900.

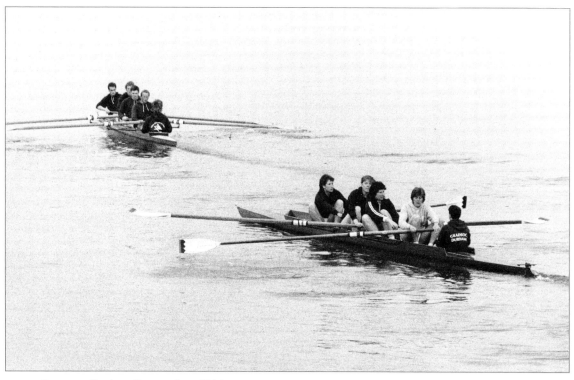

Rowers at Stockton Regatta, June 1986.

A very busy river scene, showing Ropner's shipyard and Blair's marine engineering works. Kelley's Ferry is doing good business. The earliest record of a ferry at Stockton is 1183. Although Stockton's first river bridge was completed in about 1769, the ferry service continued until the decline of the shipyards at the end of the 1920s. The ferry boats shown normally held up to sixty people, although once the total reached 108!

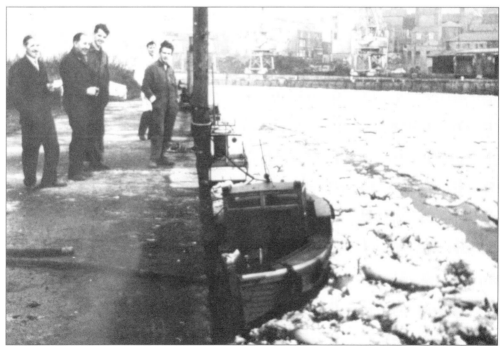

Ice floes in the Tees at Stockton, early 1960s.

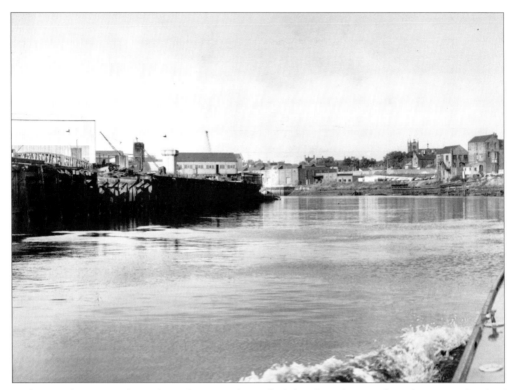

Looking up the river, with Head Wrightson Works on the left and Stockton on the right, 1964. The jib of one of the cranes on Stockton Quay is seen left of centre.

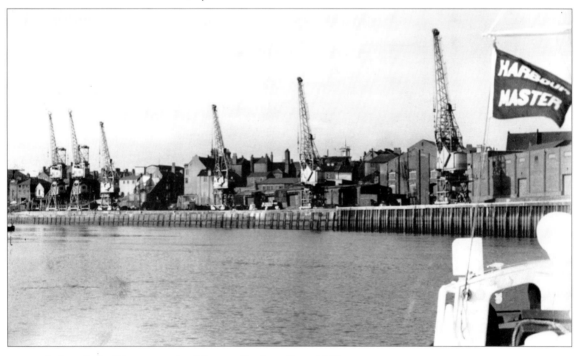

A closer look of the cranes, six of them on Stockton Quay, 1964.

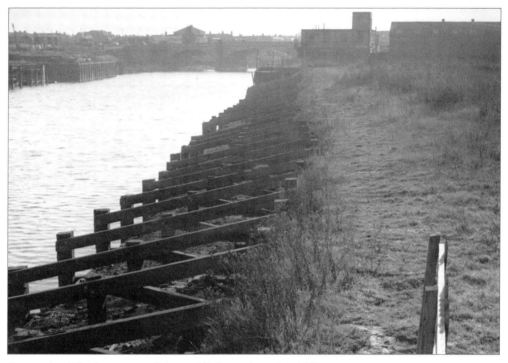

Corporation Wharf, terminus of the world's first railway, late 1960s.

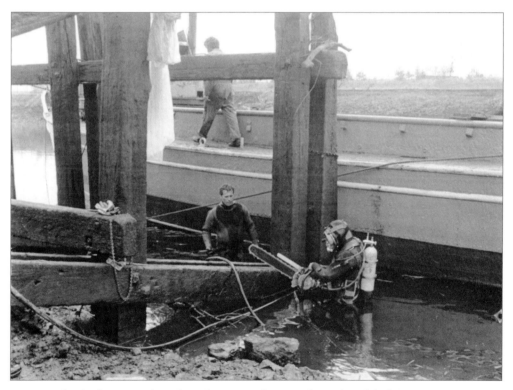

Rotting timber landing stages from the early nineteenth century being demolished, late 1960s.

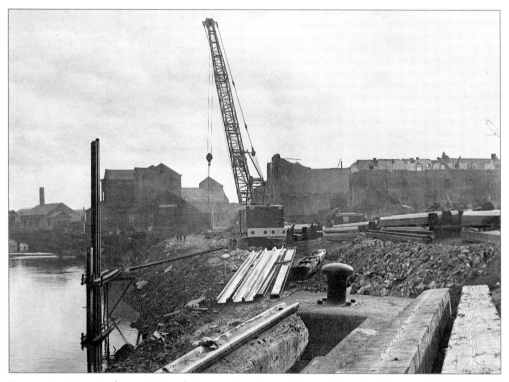

Corporation Quay, Stockton, 1969, and the scene is set for the Mayor of Teesside, Alderman Fred Webster, of Stockton, to drive the first pile to start work on laying a long-awaited eastern inner relief road.

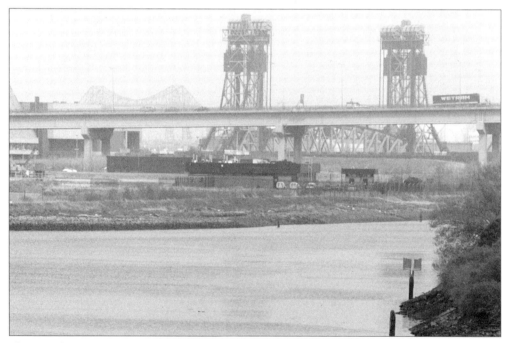

The view downstream from the Tees Barrier showing the A19 flyover, then the Newport bridge and finally the Transporter.

THE RAILWAY CONNECTION

This historic and dilapidated railway ticket office on Bridge Street, Stockton, stands close to where the first rail of the Stockton & Darlington railway was laid by Thomas Meynell on 13 May 1822. The line opened on 27 May 1825, and the track ran past the front of the now boarded-up windows.

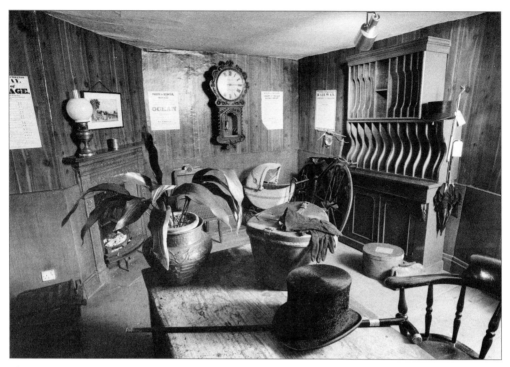

This montage of Victorian memorabilia evokes the flavour of the early days of the railways. The stationmaster's hat and stick, the penny farthing, oil lamp, aspidistra and ubiquitous railway clock tell of a bygone age when steam was king.

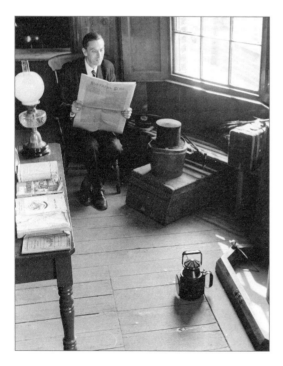

Rail travel arrived before the coming of steam, the first passenger-carrying railway in Britain being the Oystermouth Railway in South Wales in 1807. The first regular passenger service between Stockton and Darlington began in October 1825. The daily horse-drawn railway coach was called *Experiment* and took two hours to travel 12 miles. Tickets were bought at this booking office in Bridge Road. His peaked cap on the wooden bench beside him, the stationmaster is clearly enjoying his *Northern Echo*, which was established at nearby Darlington because of its railway connections.

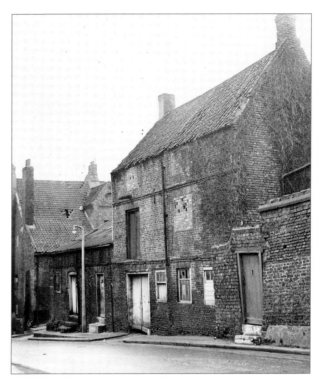

The line, routed along the quay, passed close to the old cottages.

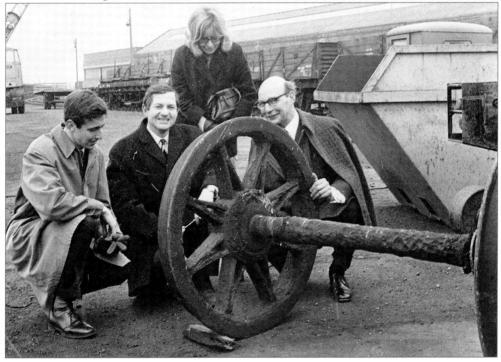

These wrought-iron wheels belonged to the original Stockton & Darlington Railway and are over 100 years old. Here they are being accepted as a gift for the Stockton Railway Museum. Pictured are, left to right, Adrian Zealand, Brian Turner, Mary Rosscamp, and Geoffrey Watson, curator of the Teesside Museums.

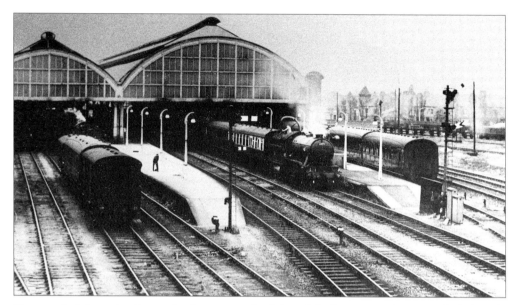

Most people believe that George Stephenson was the father of the locomotive, but many think the title should go to Timothy Hackworth (1786–1850), the engine superintendent on the Stockton & Darlington Railway. He was a staunch Methodist, refused to work on Sundays and was responsible for the growth of Methodism in the area. Passenger carriages or coaches, like these at Stockton station, took their names from the horse-drawn vehicles they replaced.

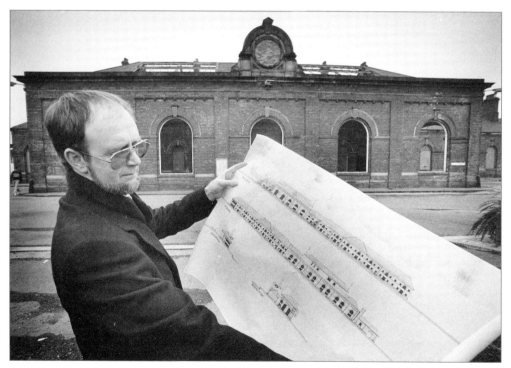

John Burrows, director of the Railway Housing Association and Benefit Fund, with a drawing of the proposed development for Stockton railway station, early 1990s.

THE FOURTH ESTATE

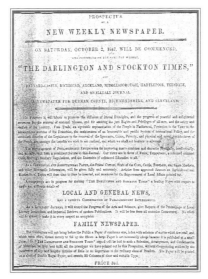

Famed as a market town serving a large population, part urban but mainly rural, Stockton needed a newspaper that would be readily acceptable to such a diverse readership. On Saturday 2 October 1847 that need was fulfilled, and today, more than 150 years later, this splendid weekly newspaper sells 32,000 copies a week over a wide area, including the Yorkshire Dales, North York Moors, the Vale of York, rural Durham, Cleveland and Stockton itself. The D & S, as it is popularly known in its North Yorkshire heartland, is one of the last newspapers in the country to have retained the ultra-traditional format. Today it has news on the front page, but until 3 October 1997, when it celebrated its 150th anniversary, it carried only advertisements on page one. The only time that this tradition was broken was to carry the result of the Richmond by-election, won by William Hague. This is how editor Malcolm Warne explained the change of policy regarding page one: 'This is a major step for an institution like the D & S but we think the time is right to make the change. The paper is renowned for the strength of its comprehensive local news coverage and we feel it is time we gave that news the shop window it deserves — on the front page. In the past the title has made a virtue out of not changing. As we head towards the millennium, our readers desire a paper which retains its traditional news content but presents it in a more attractive and readable way.'

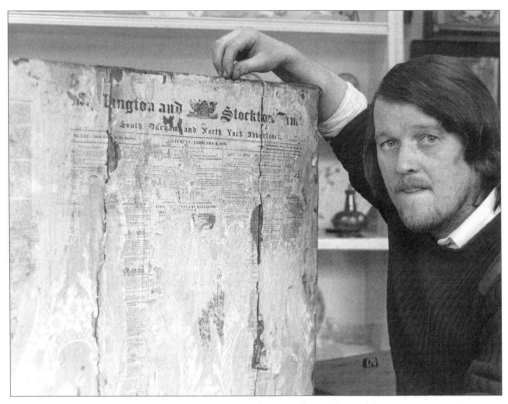

Mike Petman of Darlington with an 1858 front page, discovered on a chest of drawers.

Dedicated *D & S* staff putting the paper to bed: a far cry from when, in the early hours of Saturday 2 October 1847, in a small building off the Horsemarket, Darlington, the first hand-set copies of the paper were being run off a hand-driven flat-bed press, folded by apprentices and inspected anxiously by its two publishers. They were Henry Atkinson, who had a printing business, and George Brown, a Staindrop-born lawyer.

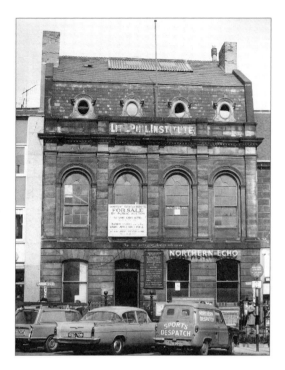

Stockton's 100-year-old Literary and Philosophical Institute, the premises of the *Northern Echo*, purchased in 1964 by an unidentified developer. The *Northern Echo* offices moved to nearby Nelson Terrace.

The King's Message of Congratulation

THE Editor (Mr. Andrew S. Stainsby) received the following letter from Sandringham in reply to a message of loyal greeting sent to H.M. the King from the "Darlington and Stockton Times" on the occasion of its centenary:—

Dear Sir,—I am commanded by the King to thank you for your letter of the 29th September, in which you conveyed a message of loyal greetings to His Majesty from the proprietors, editor, manager and staff of the "Darlington and Stockton Times" on the occasion of its centenary on October 4th next.

His Majesty was greatly interested to learn of this landmark in the history of your paper, and sends to all concerned with its production his congratulations on the completion of one hundred years of uninterrupted publication and his best wishes for the continuation of this impressive record in provincial journalism.

Yours truly,

EDMUND HOOD,

On Saturday 4 October 1947 the *D & S Times* reached its 100th birthday and received a letter of congratulation from King George VI. In prestige and influence it had grown to a greater extent than even the sponsors of the paper could have anticipated.

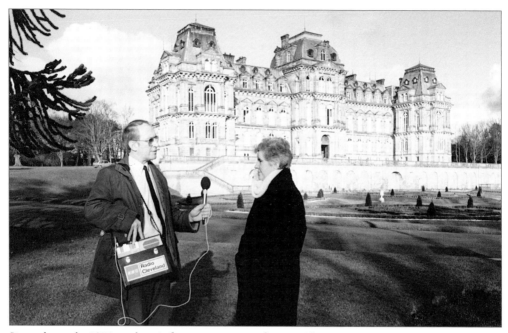

Since the early 1970s, when it first went on air above a Chinese restaurant in Linthorpe Road, Middlesbrough, Radio Cleveland has captured the hearts of countless regular listeners throughout Teesside and beyond. From the outset it has been distinctive, with its friendly informality and its identification with the area it serves so well. It produces a wide range of local interest programmes and provides both a public and a social service to the community. Radio Cleveland has always had a strong affinity with Stockton and regularly airs all aspects of Stockton life. Its outside broadcasts cover events right across the outlying areas; and here Keith Proud is conducting an interview in the grounds of Bowes Museum, Barnard Castle, for his popular Saturday morning programme 'Walkabout'.

95fm & 95.8fm

Now in its impressive new home, Radio Cleveland goes from strength to strength, thanks to its dedicated staff, including broadcaster David Peel, editor Matthew Davies, producer/presenter Neil Green, and presenters Ken Shaudon and Alan Wright, all of whom are household names in Stockton and wherever Radio Cleveland is received. Alan Wright, shown here, talks to local and national celebrities, getting to know the person behind the name, does book and film reviews and generally covers features that appeal to everyone. The wide range of its programmes, both in verbal and musical content, has so endeared Radio Cleveland to its listeners that many radio receivers are permanently set at the same spot on the dial, 95 FM.

CHAPTER SEVEN

AT WORK

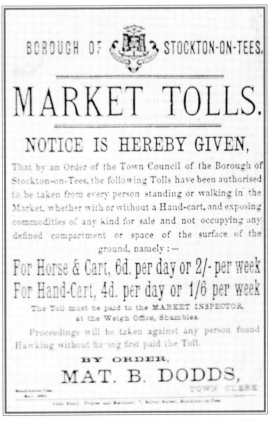

A notice of market tolls at Stockton Market, May 1846.

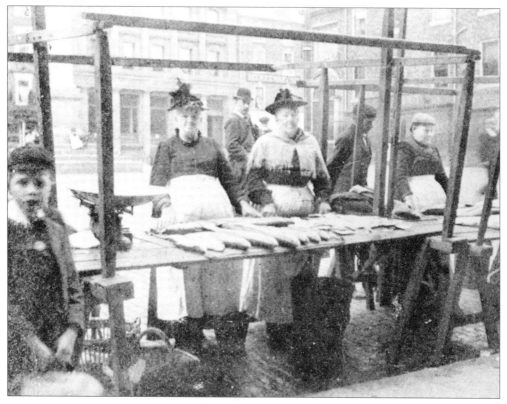

Selling salmon at Stockton market, 1902.

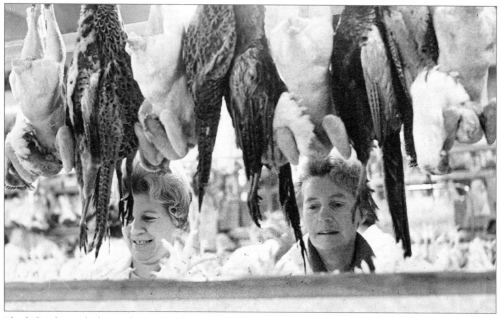

The ladies beneath the poultry at Stockton market are Mrs Gladys Meynell, right, and Mrs Freda Eden, both from Welbury, Northallerton, both of whom get up at 4 a.m. to get to market on time.

One of the Borough's standard measures kept by the clerk of the market.

The grocer and the tobacconist are shops rarely found nowadays. In town centres the grocer has been replaced by the supermarket and elsewhere by corner shops, which are much more general. The tobacconist is now rare because his products are so generally available. One, two, three, four, five: as the Player's advertisement tells you, it's the tobacco that counts.

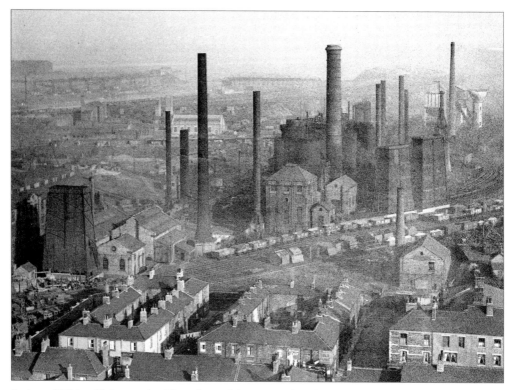

A view of Whitwell's Ironworks, Thornaby, and the surrounding district, 1920s.

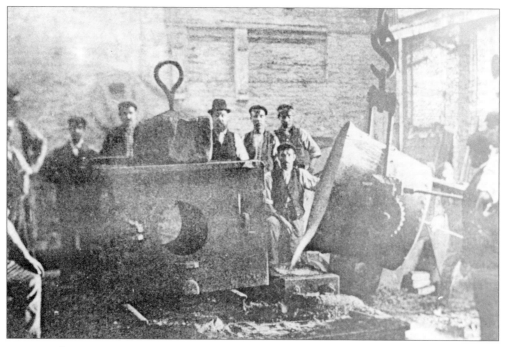

Pouring molten iron at Parkfield Foundry, *c.* 1920.

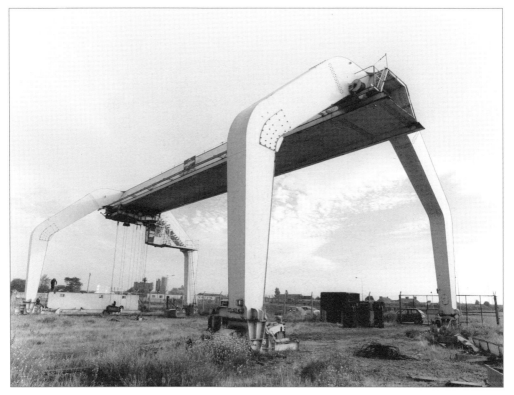

Goliath crane at Haverton Hill shipyard, Stockton, when ever-larger ships were being built there, 1963.

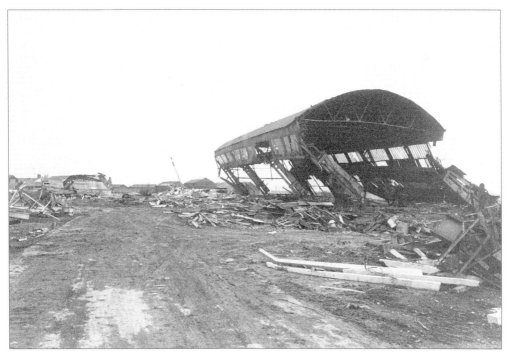

The end of an era: the demolition of Stockton's metalisation plant.

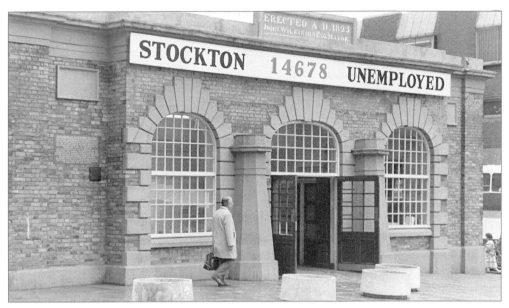

The Shambles at Stockton, erected in 1825 by the then Mayor, John Wilkinson Esq., where the town's current unemployment figure is on display.

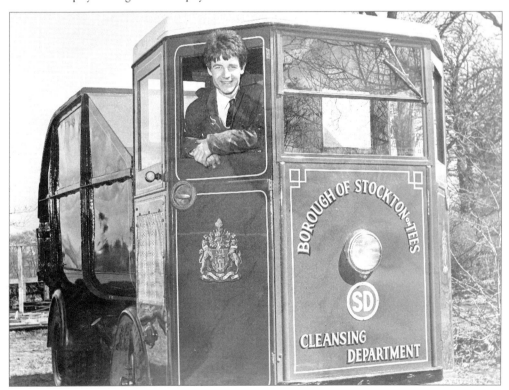

An old corporation dustcart that, having served Stockton faithfully since 1936, is now in the Museum of Social History. One unusual feature about it is that there is no steering wheel, only a handle that is wound round. It was apparently very easy to drive down narrow streets. The dustcart retains the old Stockton colour of deep green with yellow lines and lettering, while the wheelnuts are a vivid red.

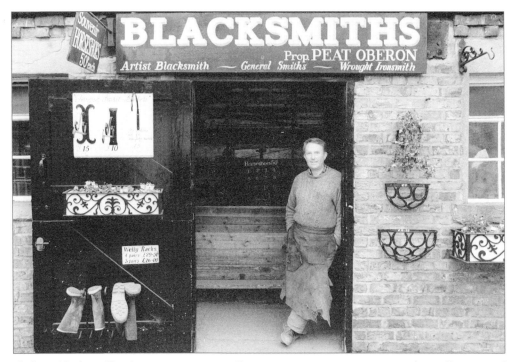

Blacksmith's shops like this one at Preston Hall Museum were once a common sight in all towns and villages throughout the land. At this one the working farrier shoes Cleveland police horses and can be seen resting after demonstrating his skills.

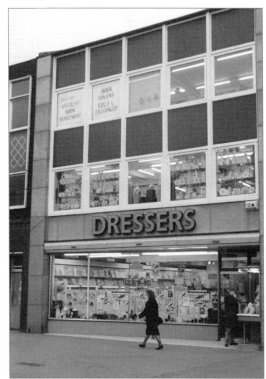

Sadly no more, this friendly family bookshop and stationers, Dressers, was a welcome haven for shoppers who appreciated that personal service with old-world charm so often missing in today's superstores, where customer consideration seems of little account. By happy chance shoppers are still able to savour the superlative service once so much a feature of Dressers Stockton and Dressers Darlington and Northallerton, where the courteous standards of yesteryear and the genuine desire to be of service are still maintained; the customer is the one who counts.

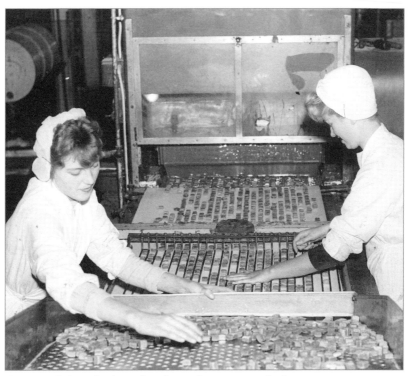

Once, Stockton people brought their wheat here when it was a tithe barn. In 1833 Paganini appeared on stage when it became the Theatre Royal, one of the oldest Georgian theatres in the country, where two plays were performed every evening. Then it became the Stockton sweet factory, Adams (Durham) Ltd.

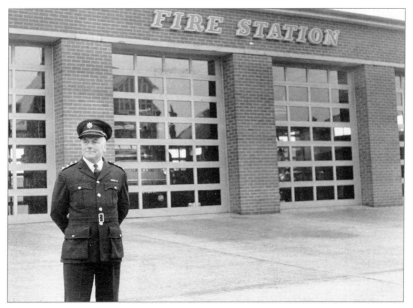

Assistant Divisional Officer of Durham County, Albert Bainbridge, outside the new £90,000 Stockton fire station in South Road, Norton. The new building integrates the old Stockton brigades into one force and houses eighty men with six appliances.

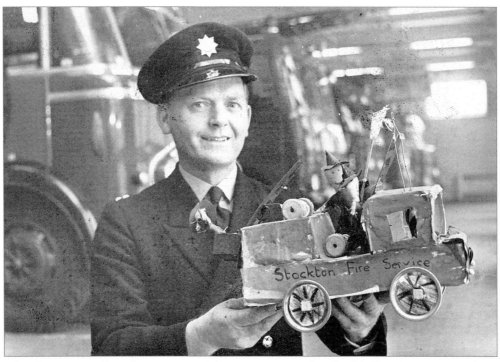

Sub-officer Jarvis with Stockton Fire Brigade's new mascot given by schoolchildren from Newton Infants' School, who were so impressed by the kindness and help the firemen gave them when they were shown round the fire station that they just had to go one better than just saying thank you. So they built a model fire engine, added a 'Diddyman' crew and presented it as a token of their appreciation. Now the model had a place of honour in the station control room.

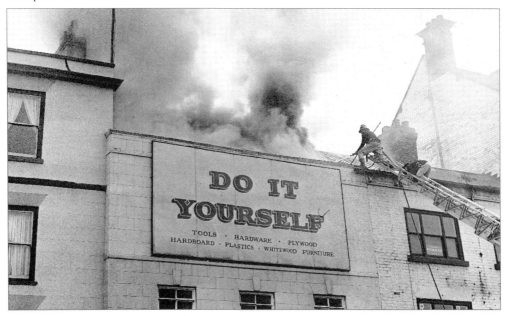

There is a moral here. If you are not familiar with matches, leave them to someone who is. Firemen on a turntable ladder fight a blaze in the Do It Yourself shop at Stockton.

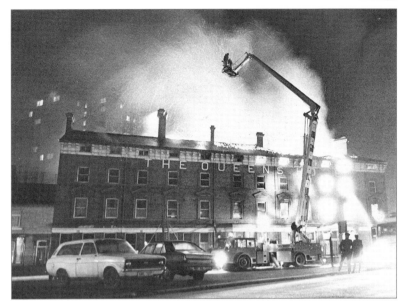

Fire at the Queens Hotel, Stockton, 30 January 1981.

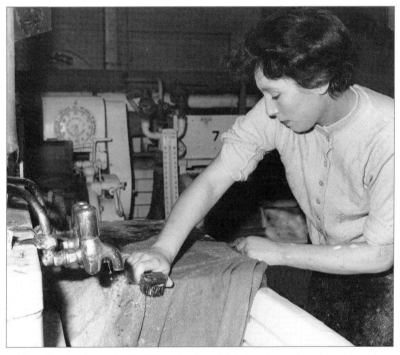

The municipal laundry, Stockton, 1965. When Stockton's Market Committee heard that the public wash-house in Bath Lane, Portrack, the second oldest wash-house in the north, was losing money, they decided to do something about it. Following consultations with their legal experts, who, in turn, looked at the implications of the 1936 Public Health Act, they decided that they could safely and with impunity change its name – to the Municipal Launderette. For 4s in 1965, 25 lb of laundry could be washed, dried and ironed in an hour. Better, said the council, than those swish launderettes where a mere 9 lb load was done for 3s 6d and you still had to pay for the drying and do your own ironing at home.

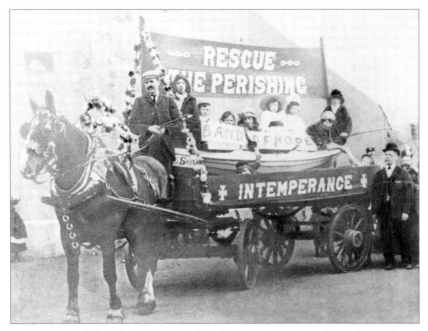

The Band of Hope fights the evils of drink near Stockton riverside in the 1890s.

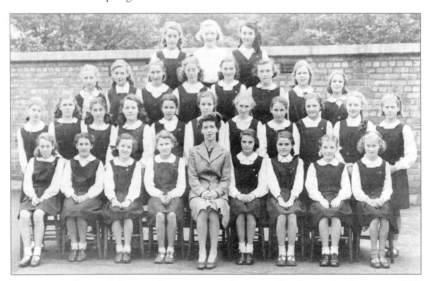

If one person were to be singled out as the originator of proper schooling in Stockton it would have to be Stockton-born pewterer Edmund Harvey (1698–1781), who in many respects was a man ahead of his time. In his Finkle Street workshop he gave a basic education to six urchins, clothed and fed them and, on Sundays, taught them the scriptures. Edmund Harvey's workshop was, almost certainly, the country's first Sunday School. Somerset Maugham wrote that people expected angels to have wings when, in fact, they looked ordinary and wore dirty overcoats. Edmund Harvey is a case in point. In 1721 a charity school for boys was opened near the parish church, girls were admitted in 1759 and in 1786 the school moved to new premises on Norton Road. In the early years of the nineteenth century a grammar school and a school of industry opened and in 1825 reading rooms and study groups at the Mechanics' Institute provided facilities for adult education. From these beginnings education in Stockton grew. The use of distinctive school uniforms enhanced the sense of belonging to a particular school, as this photo of a class in a girls' school in 1945 shows.

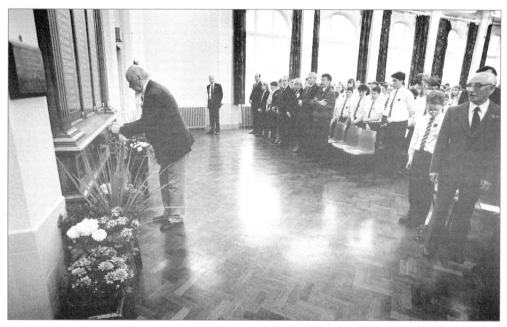

Norman Rattenby, aged 82, war veteran and former teacher at Grangefield School, lays a wreath at the school memorial during a service.

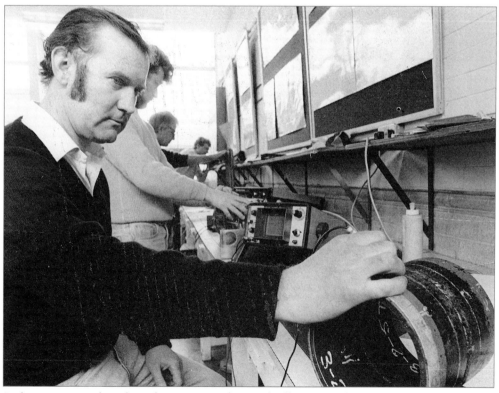

Students can now take industrial exams at Stockton and Billingham Tech. Here John Smith checks for weld faults.

Nelson Terrace Higher Grade School was opened in 1896. In 1906 it became Stockton Secondary School and in 1915 changed to Stockton Secondary School for Boys and Girls. In 1951 the pupils moved to new premises at Grangefield and between then and 1975 the building became Stockton–Billingham Technical College until 1975, before becoming the College of Further Education. It closed in 1980, and was demolished in 1984.

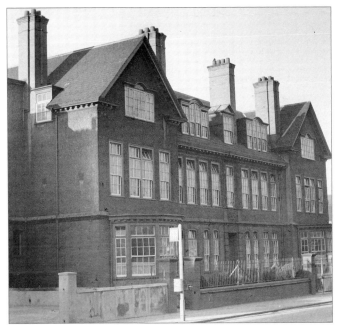

At a meeting in the Borough Hall on 19 September 1882 it was agreed to establish a high school, and consequently Stockton High School Ltd was formed to put this into effect. On 1 May 1883 Cleveland House on Bowesfield Lane was opened and nine pupils attended. In 1886 the school moved to Yarm Road, and in 1901 a site was purchased on the corner of Yarm Road and Cranbourne Terrace to replace this one. Building began in 1904, and on 19 September 1905 Queen Victoria High School for Girls was officially opened by Princess Henry of Battenberg, Queen Victoria's youngest daughter. During its first decade the number of pupils rose to over 150, many of whom gained places at Oxford and Cambridge Universities. During the early 1970s the school moved to the site of Teesside High School and the Yarm Road school building was demolished.

Taking the initiative at the opening in 1989 of the New Cleveland High Technology Initiative Centre in Stockton is Joe Telford, Manager of the Centre.

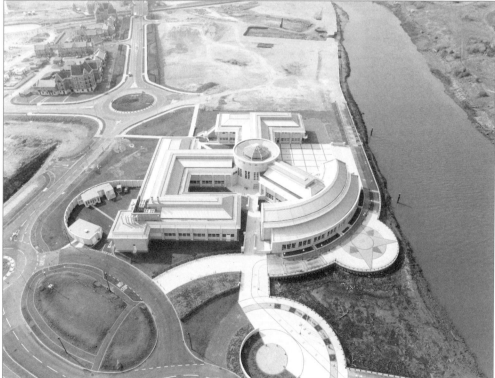

Aerial views of University College, Stockton, located on the Teesdale Development Site.

Within nine months of its opening on 8 September 1862, Stockton Surgical Hospital had admitted twenty-five patients and treated thirty-five outpatients. Situated on Sugar House Open, a passage leading from Thistle Green to the Quayside, it had six beds – which soon proved inadequate.

Built at a cost of just over £9,000, Stockton and Thornaby Hospital, sited adjacent to Bowesfield Lane, replaced Stockton Surgical Hospital. Originally it accommodated thirty-five patients, the first of which were admitted in 1877; but a wing added in 1890 and a further extension, opened in 1926 by Princess Mary, increased the accommodation to 130 beds. At the same time a nurses' home, an out-patients section, an electro-orthopaedic department and a dispensary were added. Then, in 1960, a casualty department was built; but in 1974 all the patients were transferred to newly completed North Tees Hospital, and the Stockton and Thornaby was demolished in 1977.

Built as a fever isolation hospital on Durham Road in about 1890, this building became a children's hospital in 1949 and closed in 1974.

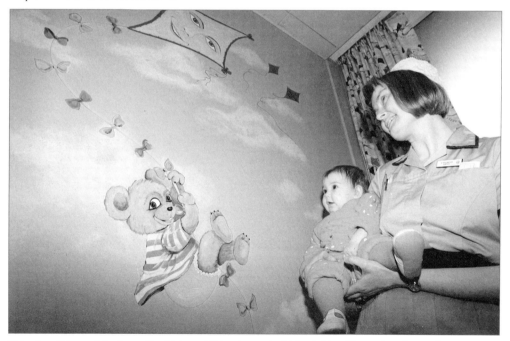

This cheerful mural by Irene Gould in a children's ward of North Tees Hospital is designed to minimise trauma in young patients. Fascinated baby Charlotte Boyle is safe in the caring arms of nurse Gill Eglington. The hospital was opened in May 1968.

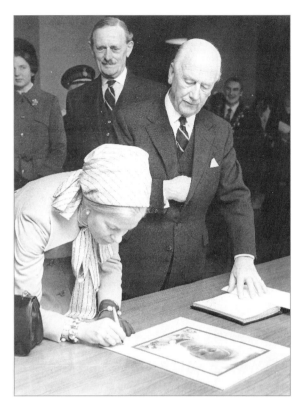

Watched by, left, Sir William Lee,
Chairman of the Northern Regional Health
Authority, and Brig. Claud Fairweather,
Chairman of the Cleveland Authority, the
Duchess of Kent autographs a photograph
of herself after officially opening the North
Tees Hospital, Stockton, May 1968.

North Tees General Hospital staff show off their new uniforms, 1968. In the centre is supervisor Jean Coates.

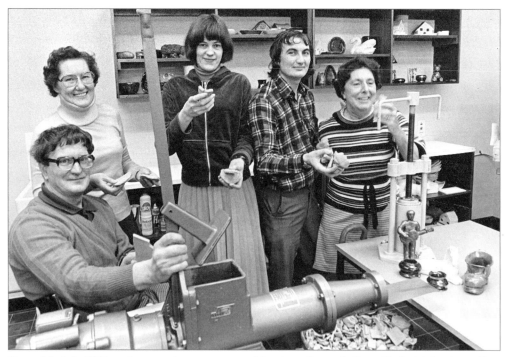

Opened in July 1976, and now an important part of Stockton Borough Council's Social Services, Alma Day Centre for the handicapped caters specifically for adults with physical disabilities.

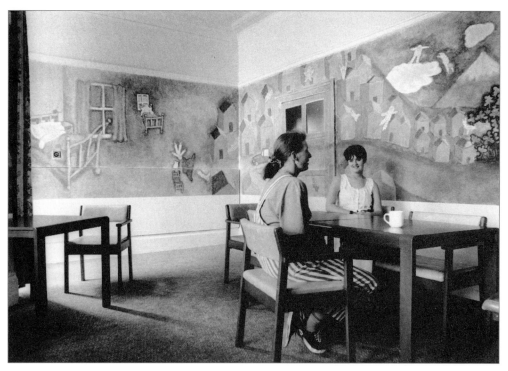

Dawn Coyle, senior care officer and Sarah Laverich, care officer, in the common room at Hartburn Lodge Residential Centre, which has been decorated with a mural by students.

AT PLAY

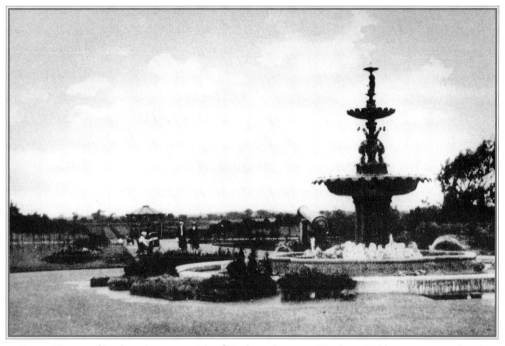

Almost 40 acres of land on the western side of Stockton, known as Hartburn Fields, were presented to the town, gratis, by Sir Robert Ropner, and became Ropner Park. It was officially opened on 4 October 1893 by the Duke and Duchess of York, who later became King George V and Queen Mary. This ornamental fountain stands at the opposite end of a straight, wide, tree-lined avenue to the park's Golden Gate entrance.

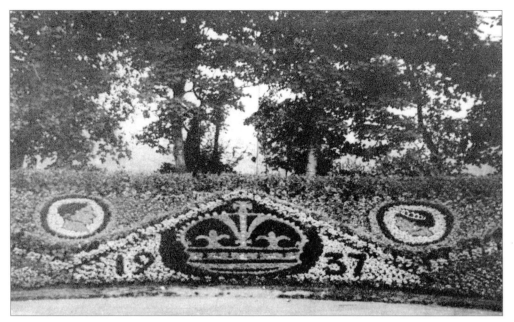

Ropner Park was tastefully landscaped; the broader avenues were straight but all the paths were set down in a series of curves. Some of the flower beds were raised both for artistic effect and to act as windbreaks. The one shown here depicts King George VI and Queen Elizabeth in floral profile, with the crown to celebrate his coronation on 12 May 1937.

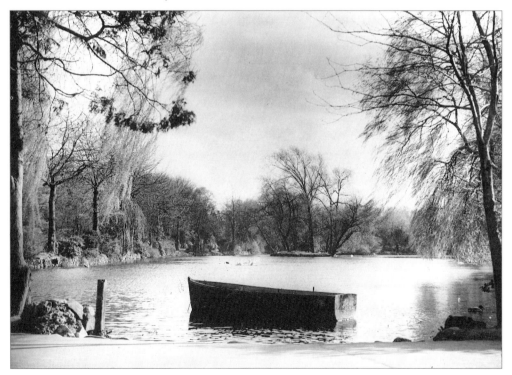

A general view of the lake in Ropner Park which, in 1994, housed a monster pike with a penchant for ducks.

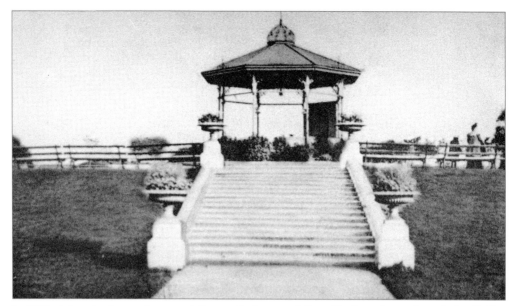

In 1893 visitors to the newly opened Ropner Park entered from Hartburn Lane, through the Golden Gate, and perambulated along a broad, tree-lined avenue to the ornamental fountain at its far end. If fancy took them they would turn left along another tree-lined avenue to the bandstand, there to listen to the band. The bandstand, like the ornamental fountain and the neat rows of trees, simply oozed Victorian elegance, and from it lilting strains of Viennese waltzes, stirring Sousa marches, catchy tunes from Gilbert and Sullivan operettas and sentimental ballads, so dear to Victorian ears and hearts, drifted on the warm air of a fine summer evening to lift the hearts of the promenaders. To celebrate the Festival of Britain in 1951 an open-air theatre was built not far away. Now both are gone.

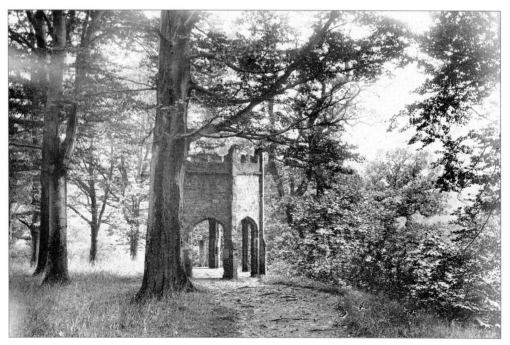

The wishing temple in Bishop Park.

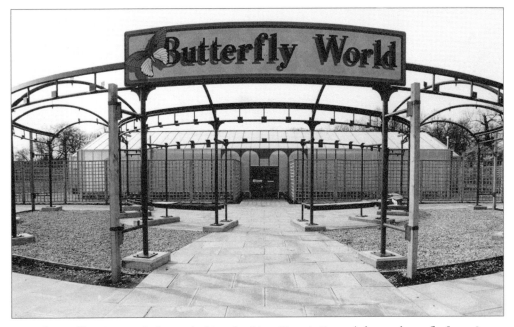

Butterfly World at Preston Park, overlooking the River Tees, is Europe's largest butterfly farm. It was opened in 1991, part of a development programme to make Preston Park a major leisure and recreational venue. Formerly the home of the Ropner family, it was leased to Ashmore, Benson and Pease Ltd in 1937. When they relinquished the lease in the mid-1940s, it was scheduled for demolition, to be replaced by a housing estate. This plan fell through because of building restrictions following the Second World War. Eventually Stockton Borough Council acquired Preston Hall and opened it as a museum on 3 June 1958. A bequest by Colonel G.O. Spence (1879–1925) of arms, armour and *objets de vertu* to Stockton Corporation to perpetuate the memory of his parents became a major feature of the museum's displays. Galleries illustrating social life from 1750 to 1900 were added, and in 1969 it was reopened as Preston Hall Museum of Social History. More recent developments include the reconstruction of a north country street of the 1890s. Surrounding parkland has been re-designed and nature trails, a children's playground and animal enclosures have been added. Then, in 1987, a £140,000 aviary was opened.

This trophy was presented to the Teesside Tennis League by Messrs R. and L. Ropner.

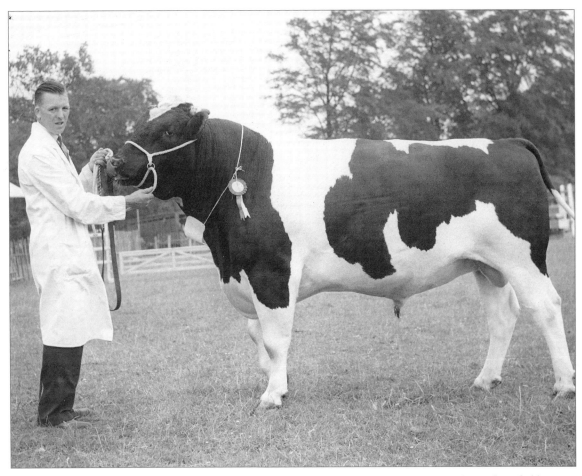

A reminder that Stockton has strong rural roots: a magnificent Friesian bull at Stockton Show, held annually in July.

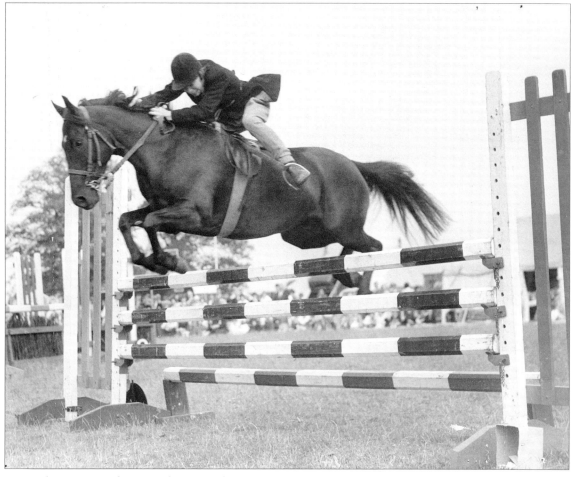

Show jumping, always popular, attracts large crowds at Stockton Show.

Carol Croft, Centre committee member and organiser of tea dances at Elm Tree Community Centre, looks after the tea while members dance.

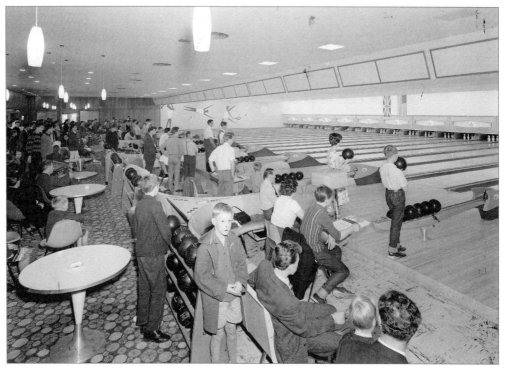

Younger Stocktonians to whom waltz, veleta, quickstep, foxtrot and tango are from a different world, would perhaps find this ten-pin bowling alley better suited to their needs. The one seen here has been superseded by a brand new one at Teesside Park.

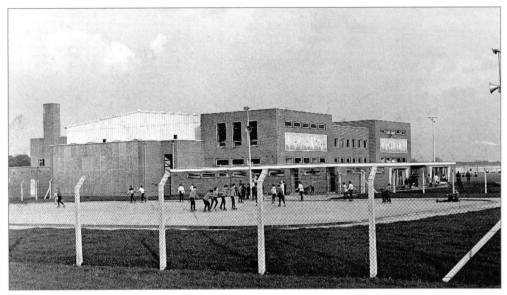

Stockton's new sports centre, opened in 1966, with a roller skating rink in the foreground.

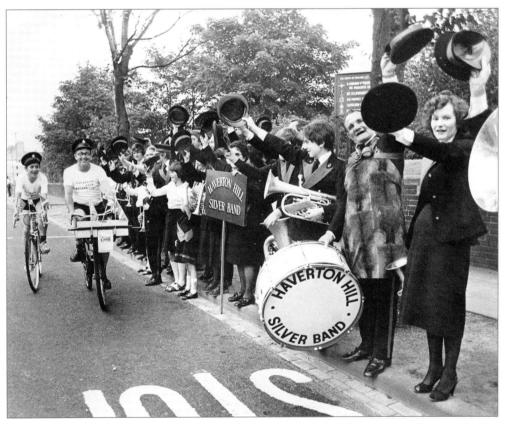

When Haverton Hill Silver Band needed new uniforms, George Nolan, 43, and his son George, 15, did a marathon cycle ride from Edinburgh to Stockton to raise funds, in 1980. Generous Stockton people are renowned for supporting worthy causes.

Gregarious conviviality is a delightful characteristic of many Stockton folk. Here, following the Queen's Silver Jubilee in 1977, the Jubilee Gang at Rushford Avenue, Stockton, formed a Neighbours Club. Back row, left to right: Nora Buxton, Elsie Patterson, Jean Price, Ella Brennan, Olga Drinkel. Front row: Ann Watson, from Canada, Teda Waites.

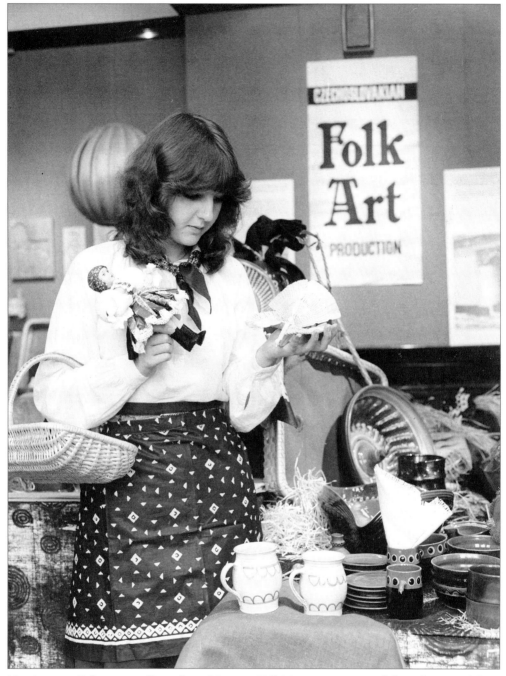

Miss Lorraine Pallister, a staff member of Preston Hall Museum, arranging folk craft material from Czechoslovakia, just one of many craft displays presented there on a regular basis.

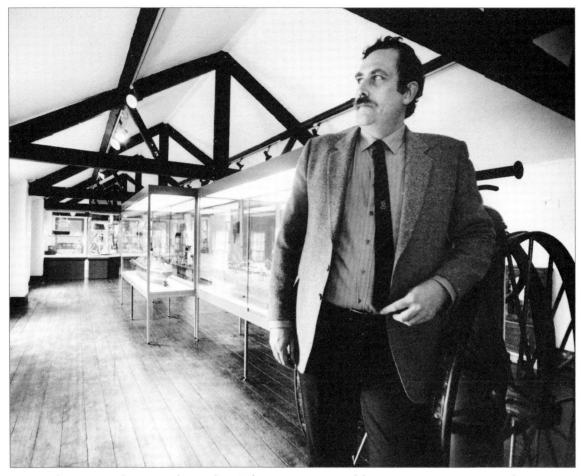

Taken in 1990, this picture shows Julian Herbert, acting curator of the Green Dragon Museum, Stockton.

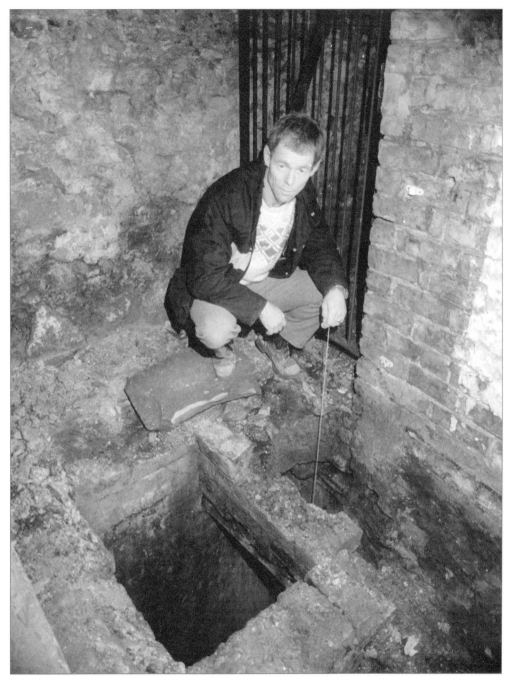

Built in antiquity at what is now Stockton's Green Dragon Museum: a medieval well.

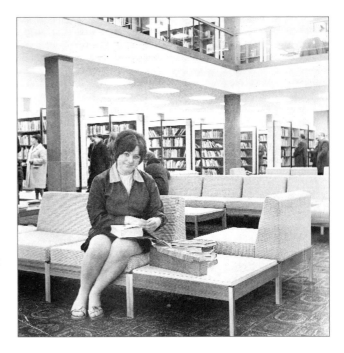

With a spacious layout and decor that is conducive to browsing, Stockton's thoroughly modern central library in Wellington Street is very inviting. It presents no parking problems to library assistant Ivy Jones. The parking problems are outside the building and involve cars.

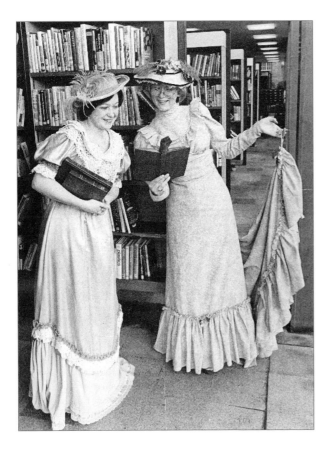

Stockton's central library opened in 1877 and has served the town well ever since. To celebrate its first hundred years, in 1977, staff wore Victorian dresses and an exhibition showed the progress of the service from its earliest days. An apocryphal story tells of a librarian who, at her wedding, had three bridesmaids instead of the two originally planned because one of her pages was missing! Assistants Sue Lockney and Joy Coulson point out that browsing the shelves is a relatively recent development for the library-goer. In the early days of the central library, assistants searched the shelves for a book at the reader's request.

When, in 1966, Stockton's newest branch library opened at Fairfield, it was so popular that within a short time only 1,500 of its original stock of 11,000 books were still on the shelves. Orders were placed for a further 4,000 to bring the total stock to 15,000. 'It's like trying to stem a flood,' admitted Mrs Sheila Simpson, the branch librarian.

RAF Association headquarters at Stockton.

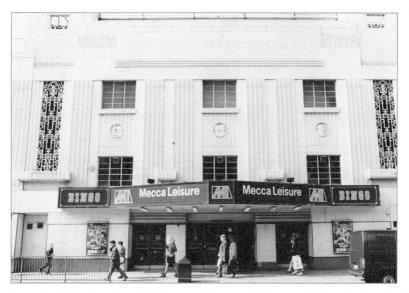

'Eyes down', as the Irish caller shouted, 'Sherwood Forest: all the trees.' Mecca Leisure Social Club is Stockton's ever-popular Bingo Club.

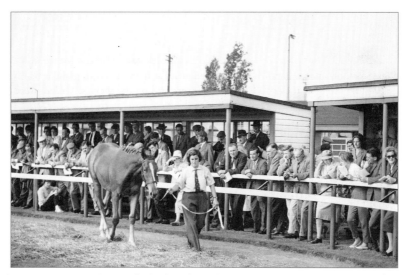

There was horse racing at Stockton as far back as the early eighteenth century when meetings were held on The Carrs, opposite the Town Hall. At one meeting in 1735 there was a 3 mile race for women, the winner being presented with a holland smock and a velvet cap, together worth 2 guineas. In 1816 a Quaker family bought the site and banned horseracing. In 1825 racing began again at Tibbersley and Fenney's Bottoms, now part of ICI Billingham. The venue was popular: the Stockton Gold Cup became an important event in the racing calendar and, with the coming of the railways, the race attracted classic horses from all over the country. Lord Londonderry's party and local gentry usually travelled to the racecourse by river, disembarking at a gangway with direct access to the Tibbersley course. The last day of the four-day meeting was a fun day, with the annual Sunday School picnic and other family events. A Mariners' Stakes was held on that day and the captains of the ships docked in the River Tees rode carthorses round the course. The sport of kings was, indeed, a happy day out for everyone. In 1855 the racecourse was moved to the Mandale site, prize money was paid in sovereigns and a day at the races became fashionable. This photo, in 1961, is of a northern blood-stock sale in progress at Mandale Racecourse.

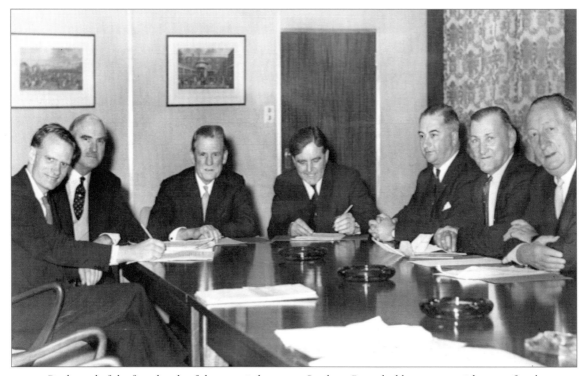

By the end of the first decade of the twentieth century Stockton Races had become a social event of such importance that the latest London fashions were displayed there. The *Sporting Times* commented: 'The paddock at Stockton showed more mould of form, for ladies, not horses. The Teesside sons of toil should be grateful for the opportunity to feast their eyes on beautiful ladies dressed in their finery.' Guests of the racecourse company were entertained lavishly, but the spectators and jockeys alike were suspicious of southerners who 'came to spoil their sport'. In August 1905, to mark fifty years of racing on the Mandale Racecourse, the racecourse company organised a summer jubilee, at which the big race was the Stockton Jubilee Cup with a purse of 750 sovereigns. The winner was 'Her Majesty', owned by Lord Derby, who had three winners that afternoon. A new stand was opened in 1955, complete with refreshment room, bar and toilet facilities to mark the course's 100th anniversary. In 1979 further improvements costing £1.7m were opened by Princess Anne, but in July 1981 the racecourse company crashed, owing Barclays Bank £750,000. Valiant efforts were made to make the racecourse viable. A delegation from Teesside met members of the Horserace Betting Levy Board in London to plead for continued support and came away much more hopeful, following the Board's decision six months earlier that they would not be able to give financial aid to Stockton Racecourse after 1966. Those present at the meeting were, left to right, Dr Jeremy Bray MP, Sir Rupert Brazier-Creagh, Field Marshal Lord Harding, Councillor John Hudson, Mr Robert Russell, Councillor James Kidd and Mr George Wigg MP. They are in the chairman's room at the Levy Board's headquarters in London where they discussed the future of Stockton Racecourse. Various uses were suggested for the site, including a heliport, but London developer Brookmount's plan for a hypermarket and leisure complex won the day.

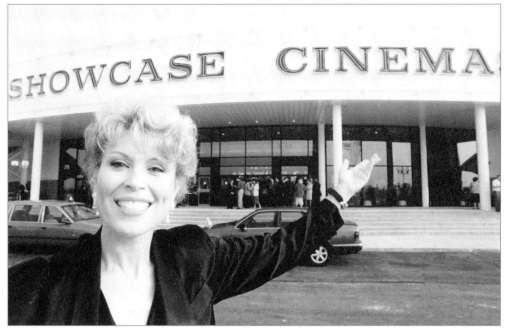

Police Academy star Leslie Easterbrook at the opening of Teesside Park's fourteen-screen cinema complex. The leisure park also includes a 26-lane bowling alley and laser combat centre, restaurants and bars.

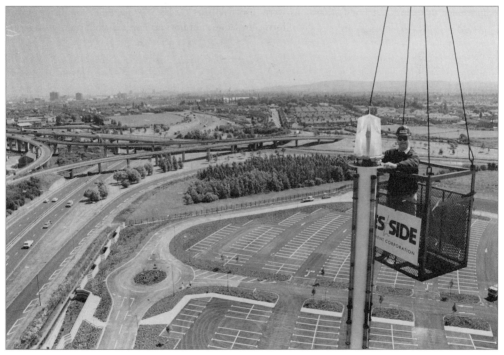

The tower on top of the leisure complex on the former Stockton Racecourse site, an £80m project covering 200 acres, including a 75,000 sq ft Morrison's supermarket and the biggest British Gas showroom in the north-east.

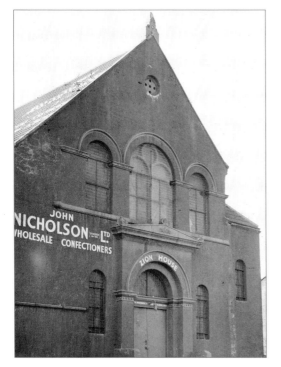

Zion House, *c.* 1950. When application was made by its owner, Mr Herman Markovic, to turn it into Stockton's first nightclub, some town councillors had reservations because the building looks too much like a church.

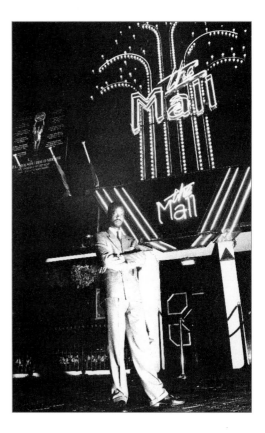

The manager of the Mall nightclub, which began as a cinema in 1935.

In its heyday in the mid-1960s the Club Fiesta lived up to its name and packed 'em in. The acts were good and the audiences appreciative – but times change.

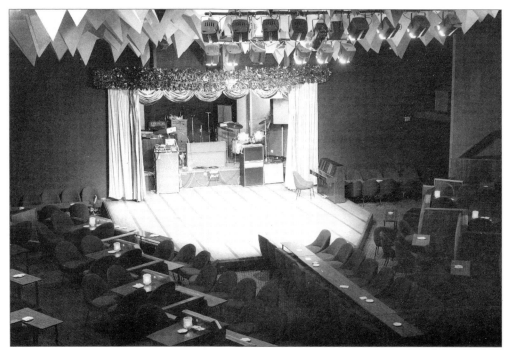

Inside the Club Fiesta, the very heart of the nightclub, where it all happens. The rows of tables are tiered to enable patrons seated further away from the stage to have as unobstructed a view of the performing artistes as possible. The carefully contrived atmosphere enables patrons to forget their inhibitions, relax and enjoy themselves. They might as well, because nightclubbing is not cheap.

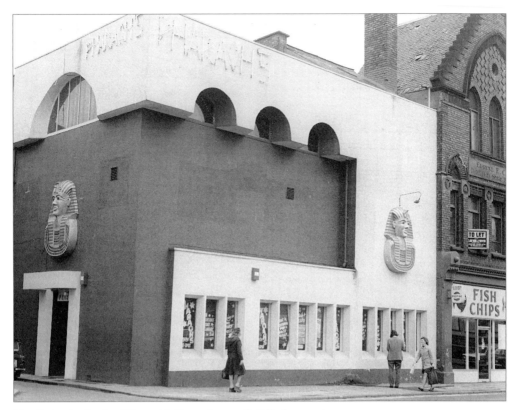

The distinctive façade of Pharaoh's Disco, frequently full of mummies.

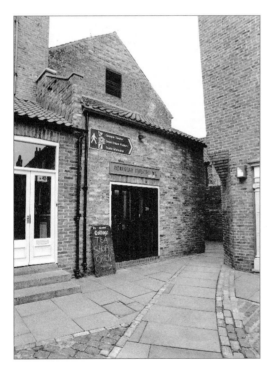

I find it fascinating, hilarious really, that a tithe barn which Thomas Bates converted into a theatre in 1766 should still have accepted the tithe, renamed the agent's 10 per cent, to people purveying corn – as he managed a group of comedians! The tithe barn became Stockton's tiny Georgian Theatre, one of many provincial theatres to be built during the prosperous years of the eighteenth century. Having owned the Georgian Theatre for twenty-odd years, Bates sold it to a well-known actor, James Cawdell, who turned the debt-ridden theatre into a profitable enterprise. Other owners failed to match Cawdell's financial success, but the theatre remained in business, becoming known during the 1850s as the Royal.

The music hall, growing from amateur free-for-alls in the back rooms of pubs, became the major leisure industry of its time from the mid-nineteenth century to the end of the First World War, and the legitimate theatre soon degenerated into music hall. This is what happened to the Georgian Theatre, but it was not a success, and the theatre closed. It was converted into a Salvation Army headquarters before becoming J.F. Smith's Nebo Sweet Factory. To paraphrase a more recent music hall act, Mr and Mrs Smith's two little boys, James and Donald, founded the factory, Donald, a bachelor, living until 1953. He was 93 years old when he died. Donald produced a cough sweet that became a household name in the north-east. There were sacks of sugar under the stage, alongside the roasting machines, and women in

sugar-dusted overalls heaved great copper pans off the stove and poured molten toffee into cooling trays. So the magic of the Georgian Theatre was maintained. Anyone entering what for so many years had been a dream factory would see sugar, glucose, water and a magic ingredient, 'It', become transformed into cinder toffee, nut toffee, crunchy toffee, spearmint drops, malt bricks, mint humbugs, herbal candy, 'winter warmers' to soothe sore throats, lemon fizzes and sherbet. The magic remained; and if you do not believe in magic, the loss is yours, for if you do not believe in it you will never find it.

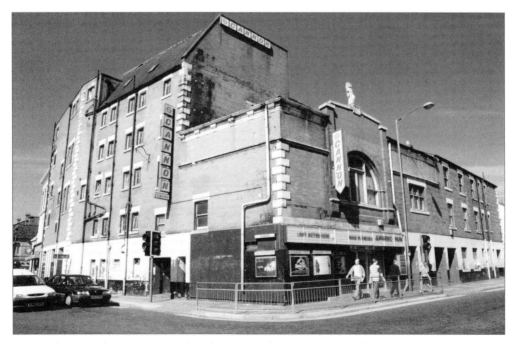

In 1905 the Hippodrome was opened on the corner of Dovecot Street and Prince Regent Street. During the eighty-eight years of its existence it was re-named the Classic, then the Essoldo and finally the Cannon. It began as a theatre, then, following a fire on 8 November 1932, reopened as a cinema. In the immediate post-Second World War years it reverted to variety, but ended its days as a cinema.

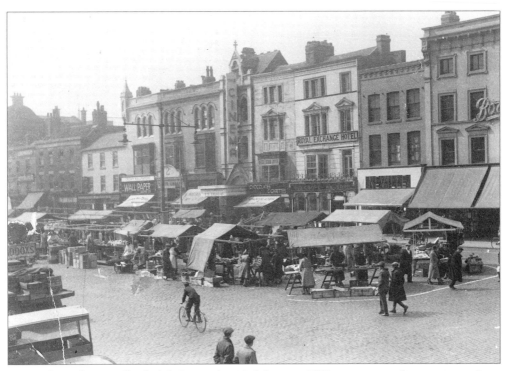

In 1910 the Exchange Hall, which had opened on High Street in 1875, was converted into a cinema. Later its name changed to The Cinema because this name was more suitable. On 28 February 1937 The Cinema suffered fire damage, but reopened on 13 June the following year. In 1964 it closed as a cinema and became Essoldo Bingo.

The foundation stone of the Castle Theatre, built near the site of Stockton Castle, was laid by Mrs Richard Murray of Harrogate on 3 October 1907. Within a year, on 31 July 1908, it opened with *The Lady of Lyons*. In about 1911 or 1912 the theatre was converted to show films and was renamed the Empire Theatre. During its final years it housed bingo; it closed in 1961 and was demolished. In 1970 the Swallow Hotel was built on the site.

On 6 August 1866 a new theatre was opened next to Yarm Lane; it was called The New Theatre Royal, and burned down on 28 August 1906. In 1878 another theatre, The Royal Star Theatre, was opened at a cost of £8,000 in Bishop Street. Five years later, early in 1883, its ceiling was decorated with gold leaf, and within months it, too, burned down. It was rebuilt and reopened as a music hall, The Grand Theatre of Varieties, in 1891, but was again damaged by fire on 12 April 1892. Again it was reopened as a theatre in the 1890s and attracted first-class artistes. Between 1932 and 1936, when it closed, the Grand was the only live theatre in Stockton. It reopened as the Plaza Cinema, closed in 1959, became a furniture store and was badly damaged by fire on 28 June 1962. It has now been demolished. Stockton had three Globe theatres, the first being pre-First World War. It was demolished in about 1925 and replaced with another Globe with a larger seating capacity. It closed in early 1935 for major alterations and reopened, with an Art Deco façade, on 16 December of that year, giving live shows. ABC bought it, and it became a cinema presenting occasional live shows, including ballet

and opera. During the 1960s it became a venue for many well-known pop groups. Attempts were made to bring back genuine theatre, but they failed, and in 1978 it became a Mecca Bingo Hall.

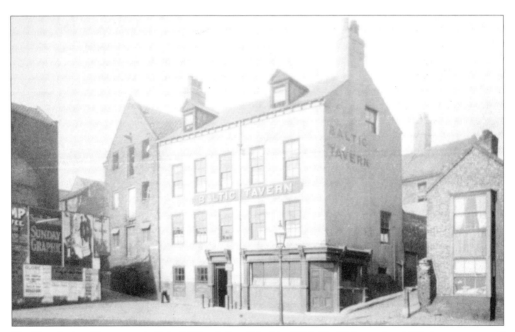

The Blue Anchor Tavern was built in 1826 and demolished in 1929. On 30 September 1889, by now renamed the Baltic Tavern, this fully licensed copyhold building with yard, stable and outbuildings and occupied by a Henry Dixon was put up for auction by Thomas Bowman, auctioneer of Darlington. The asking price was £910.

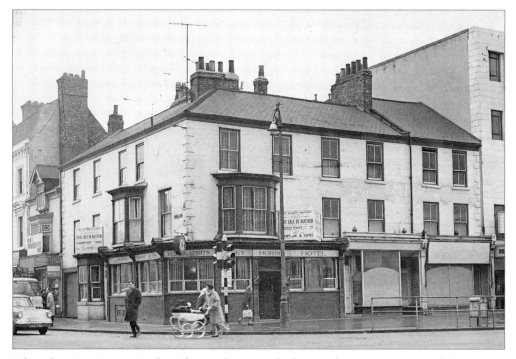

When the Grey Horse Hotel, a Flowers house, and adjacent shops were auctioned for site re-development, the price was £75,000. The Grey Horse was about eighty years old and stood on the site of an old coaching inn. The landlord, Charles Stockdale, who had been in the licensing trade since 1919, took over the Grey Horse in 1942. Before that he was the licensee of the Rolling Mills Arms, Portrack. He was the father of 'Gentleman Jim' Stockdale, the professional wrestler. The disappearance of the Grey Horse left Stockton High Street with nine public houses, and left Flowers with three in the town.

A regular enjoying a pint in the Sun Inn, Stockton. His radiant smile transcends time. The Sun Inn continues to do good business.

The Drum and Monkey was damaged by fire in 1986.

Once there were three pubs in Garbutt Street, near the town centre – the Star Inn, the Grand and the Kings Head – all of which have gone. There was another Kings Head, a Cameron's house, in Lawson Street. In 1969, when this photo was taken, there was a twist to the demolition story: the pub remained but the street had gone!

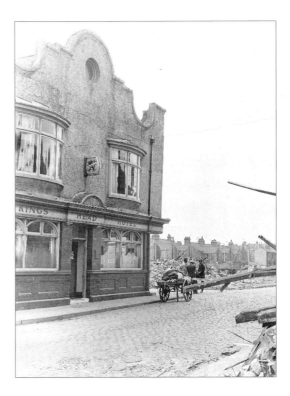

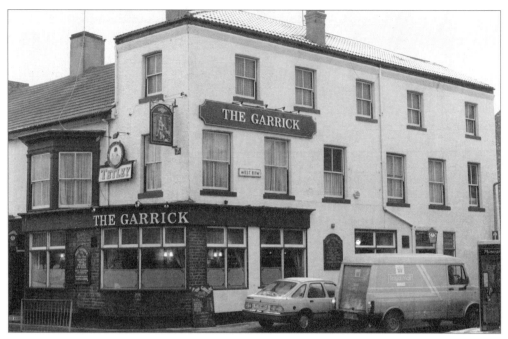

An exterior shot of The Garrick, a Tetley house, on the corner of West Row and Yarm Lane, Stockton. It is still 'packing them in'.

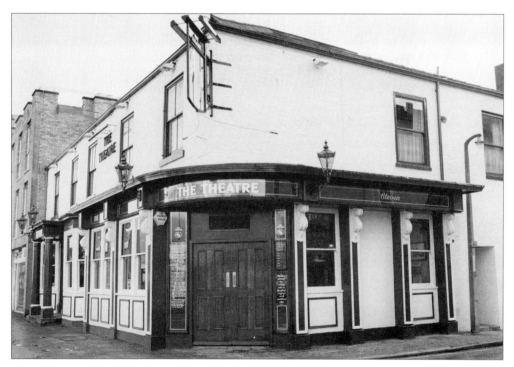

The Theatre public house stands across the road from the Garrick. It was built by a local soda manufacturer, Thomas Wright, and opened on 8 July 1870. The Theatre Royal stood nearby, and in appearance they were much alike. The Theatre Royal is no more, but The Theatre continues to look after its patrons.

The now demolished Greyhound on Corporation Wharf was an imposing red-brick building standing close to the Tees. One of its rooms, the Captain's Bar, was where seamen were paid at the end of a voyage. It had an upstairs concert room, seldom used, and downstairs a public bar where some of the money collected in the Captain's Bar was spent.

The first reference to Stockton's oldest pub is 1485 and it could be much older than that. When Stockton Castle was demolished, two pillars of blue Frosterley marble were removed from the rubble and stood up outside the pub. That is how it came to be known as the Blue Post Inn. Blue was an apt colour because at one time the inn was a notorious watering hole for the local ladies of the night. It is fitting that Stockton's oldest pub should have housed the world's oldest profession. Pub names frequently provide a link with the past and give a place roots, so it is a pity that the Blue Post has been renamed Trader Jacks and is known simply as Traders. The Blue Post gave its name to Blue Post Yard, and in the latter part of the last century farmers in Stockton for the weekly cattle mart stayed there.

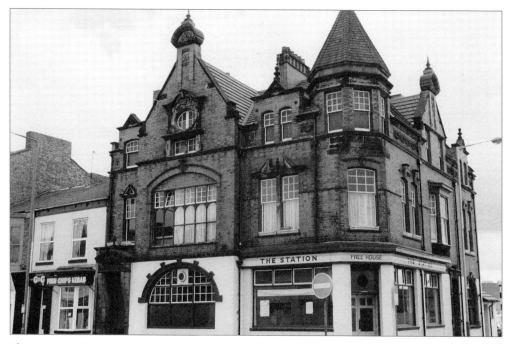

The Station at the corner of Bishopton Lane and Leeds Street is one of Stockton's more traditional and distinctive-looking pubs. It is so named because it is close to Stockton's railway station. Built in 1898, it is a traditional pub with no frills. It has a games room upstairs, ladies' and men's darts teams and two pool teams. It is home to Station Football Club, playing soccer in the local Sunday League.

The Turks Head, a Vaux pub, now demolished, was named after a type of knot tied at the end of ropes produced at a nearby ropeworks. The knot resembled a turban, hence the pub's name. Local brewery, Vaux, has been brewing fine ales and lager since 1806.

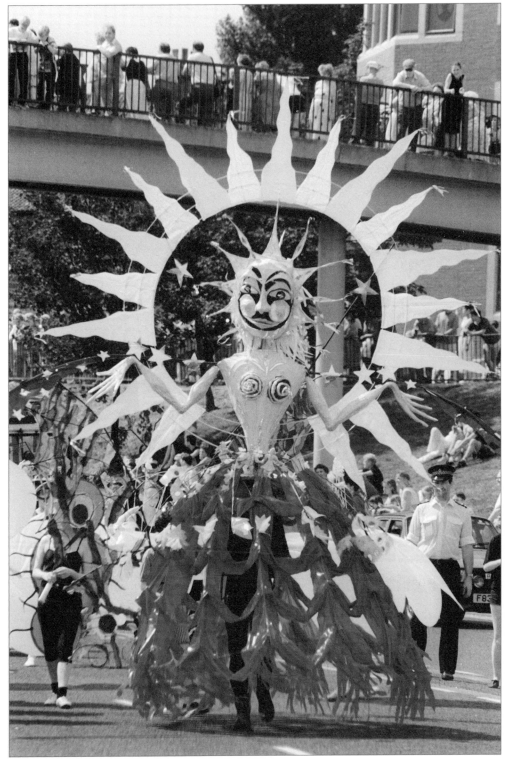

The community pageant wends its way through the streets of Stockton.

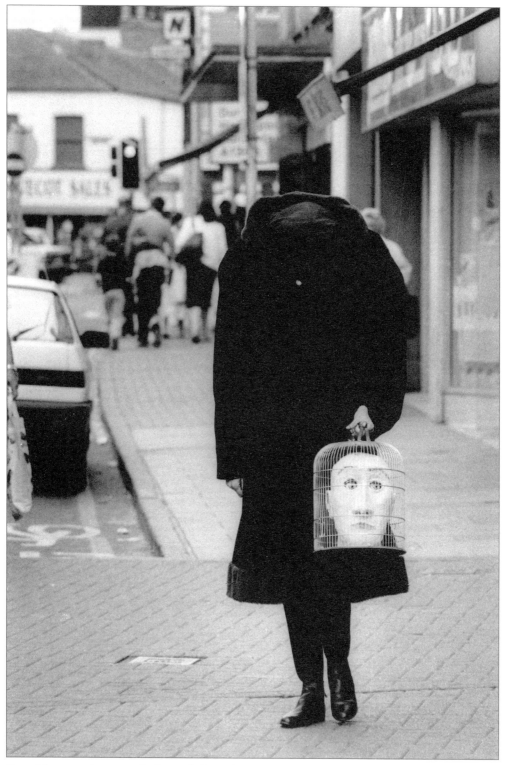

Part of the entertainment at the Riverside Festival.

The head of the Community Carnival procession passing The Garrick.

One of the visitors interested in a Spitfire replica on display in the grounds of Preston Park during Stockton Carnival, 1995.

Philip Seymour (9) assisted by Cpl Malcolm Priestley of the 4–5th Battalion of the Green Howards (TA) on the shooting range at the Stockton Carnival at Preston Park, 1995.

A member of the Neighbourhood Watch group in Stockton High Street. Neighbourhood Watch is the name of a Newcastle upon Tyne street theatre company, an integral part of Stockton's Festival.

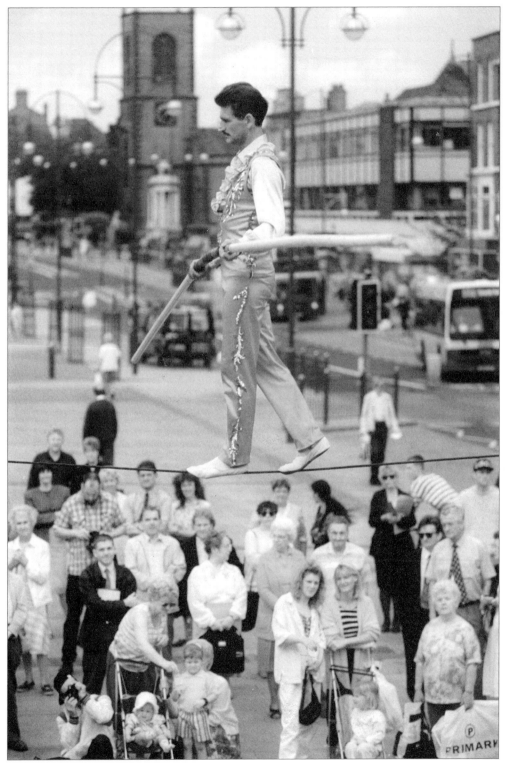

Carl Carlin on his high wire in Stockton.

Stockton Riverside Festival, 1992: a highlight.

A Cuban dance group performing at the grand finale of Stockton Riverside Festival.

STOCKTON'S PRIDE

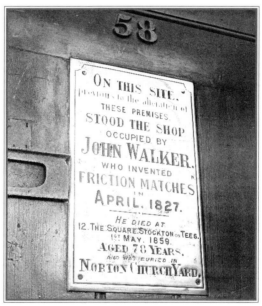

John Walker was born at 104 High Street on 29 May 1781. He was educated locally, and on leaving school became apprenticed to a local surgeon. He then moved first to Durham, then to London, where he qualified as a surgeon. Returning to Stockton, he gave up his career as a surgeon and joined a firm of druggists. In 1819 he set up in business as a chemist and druggist at 58 High Street. While running his business he experimented to find a means of igniting a compound by friction and in 1826 he succeeded. He invented what he called 'friction lights', the very first friction matches. An entry dated 7 April 1827 in a book he kept for recording sales shows the first reference to his discovery. Michael Faraday, who discovered electromagnetic induction, the basis of electric power generation, visited Walker to encourage him to patent his discovery and manufacture matches on a greater scale. The visit was not a success. Walker showed no interest in patenting his discovery, being content to leave the match side of his business as a sideline – as he did not realise how important his discovery was. He remained in business until 1858 and died in May of the following year at his home; he is buried in Norton churchyard.

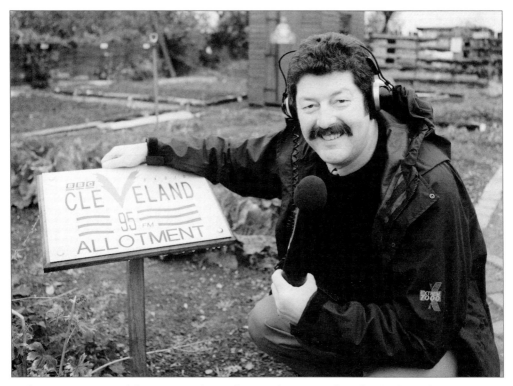

Paul Frost, presenter of the very popular Paul Frost Show on Radio Cleveland. Stockton-born Paul personifies all that Teessiders love and hold dear. He really is a credit to Stockton and Radio Cleveland.

Richard Griffiths was born in 1948 at Thornaby. His theatrical debut was in Harrogate, from where he joined the Royal Shakespeare Company before moving on to television in series like 'A Kind of Loving', 'Birds of Prey' and 'Pie In the Sky'. His film work includes *Chariots of Fire*, *Greystoke* and *Blame It on the Bellboy*.

Every night, when the moon shines bright,
The Miller's ghost is seen.
He walks the track with a sack on his back,
And his earhole painted green.

With this snatch of verse, Will Hay's sceptical master, Mr Porter, deflates Moore Marriott's morbid retelling of the ghostly couplet about One Eyed Joe, the Miller in the famous Gaumont British comedy, *Oh, Mr Porter*, made in 1938. This was his most acclaimed film. Born on 6 December 1888 in a terraced house, 23 Durham Street, off Bishopton Lane, Will Hay's birth was registered at Stockton Register Office on 18 January 1889. On leaving school he became apprenticed as an engineer and in his free time entertained at charity shows, becoming a professional when he was 20. Throughout his stage career, which lasted for almost twenty-five years, he remained faithful to his schoolmaster role. His first film, *Know Your Apples*, was made in 1933, and during the next decade he made a further eighteen, the last two being *The Goose Steps Out* and *My Learned Friend* in 1944. His screen image was completely at odds with his private achievements as a respected amateur astronomer. He wrote a book on the subject, *Through My Telescope*, published in 1935, and that year discovered a spot on Saturn. He was prouder of this than of his show business accolades. He died at his London home in 1949, having never returned to Stockton, which he left as a baby.

Frank Middlemass was born in Stockton in what is now a hotel on the High Road. His long career on stage, radio and television included probably his best-known role, Dan Archer, in the long-running serial, *The Archers*, which he played for four years. He was the old doctor in *Heartbeat* when the series first started.

Paul Greenwood was born in Stockton in 1943 and has done much television and stage work. He was PC Penrose, known as 'Rosie', in a television serial about a young copper, filmed at Scarborough. He has made at least one film, *The Lovers*, based on the television series of the same name.

Mary Jane Stainton was born in Stockton in 1888, the same year as Will Hay, and emigrated to America with her two daughters, where she appeared in a 1915 film, *The Melting Pot*.

Born two doors away from where Will Hay was born, in 1890, Ivy Close became a silent movie star when others like Charlie Chaplin, Rudolph Valentino and Gloria Swanson were emerging. She was the daughter of the manager of Samuel's Jewellery in Stockton and had two brothers and a sister. In 1908, when the *Daily Mirror* organised the first ever national beauty contest to counter American claims that the best-looking women lived on their side of the Atlantic, she was one of 15,000 hopefuls to enter, despite opposition from her father – who changed his mind when she won. Dubbed 'the most beautiful woman in Britain', Ivy was a typically English beauty, 5 ft 4 in tall, with fair hair and blue eyes. She fell in love with a *Daily Mirror* photographer, Elwin Neame, sent by the paper to take her picture. They married in 1912 and Elwin, engrossed with the silver screen, made a silent movie of her which so impressed British producer, Cecil Hepworth, that he set up Close Productions. In 1914 Ivy made her first feature film *The Lure of London*, and in 1916 signed a deal with the famous Kalem Comedy Company in Florida, then America's movie capital. On Saturday 13 May of that year she sailed for New York. Ivy appeared in about forty-five films, but gave it all up in 1922 at Elwin's request to look after their sons. Elwin was killed in a motor-cycle accident in 1923, leaving her almost destitute. She tried to revive her career, but by 1930 was reduced to playing bit parts. She returned to England and lived 'in the depth of poverty in a Bayswater flat'. Under the headline 'Stockton Girl Cursed By Beauty' the *Gazette* commented that beauty 'had once again proved itself a curse rather than a blessing'. Ivy Neame died on 4 December 1968 at Goring-on-Thames. Her son, Ronald, became a leading director and producer whose classic films include *In Which We Serve, The Prime of Miss Jean Brodie* and *Brief Encounter*.

INTO THE MILLENNIUM

Euan Cresswell, Regional Manager of Wimpey Homes, welcomes Mike O'Brien, Mayor of Stockton between April 1991 and March 1992, and HRH Queen Victoria and Prince 'Bertie' to Victoria Lock, Wimpey's prestigious multi-million pound development at Teesdale, built on the land where Mrs Thatcher made her famous walk into the wilderness in 1987 following her general election victory. Her mission was to spread a little of the affluence in which the south was basking to areas like Teesside where the need was greatest. Cynicism surrounded her visit, as critics questioned whether the area's 50,000 lost jobs would ever be replaced, because the traditional heavy industries, steel-making and the docks among them, were dying on their feet. In 1948 more than half of Teesside's 150,000 workforce was employed in iron and steel manufacture, chemicals, ship-building and engineering. But the decline was starting. Between 1951 and 1961 the number of men employed in ship-building and repair fell from 4,100 to 1,700. From the early '70s steel manufacturing, which at its peak employed almost 35,000, lost some 2,000 every two or three years. In 1980 ICI employed 22,600 workers, but by 1994 the figure had dropped to just 9,000. In 1987 Smiths Dock, the last yard on the Tees, closed with the loss of 1,300 jobs. Mrs Thatcher's visit was to change Teesside's direction from the road to nowhere to the road to prosperity. She launched the Teesside Development Corporation, a body charged with re-invigorating the area. The task was formidable but the will to make a success of it was there. TDC chairman, Ron Norman, summed it up like this: 'People from Leeds, Newcastle, and even London will be coming to Teesside because of the facilities which will be there.' Old Teesside has gone and will never return – but the future is bright.

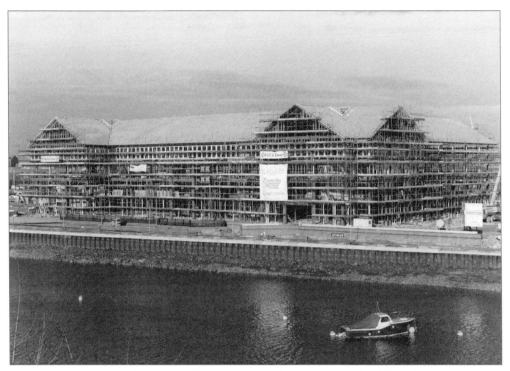

Dunedin House on Riverside Quay, an office development by Murray BS Ltd, while under construction.

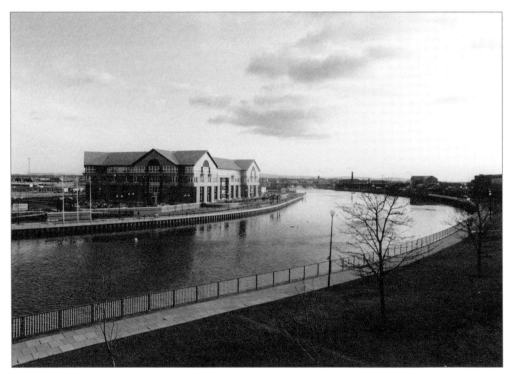

The completed building, a vast improvement to the land on the inside of the bend in the Tees at Stockton.

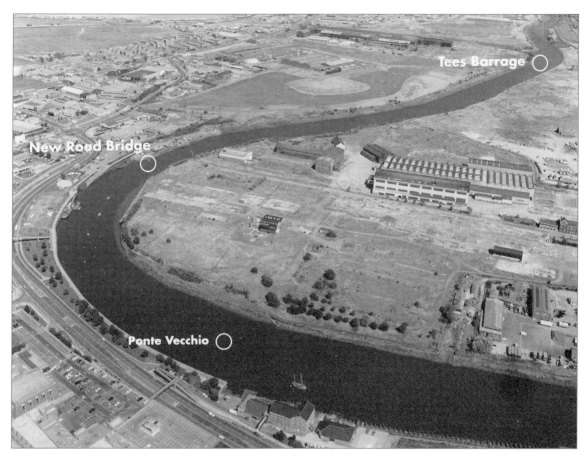

An aerial view of the Teesdale site, May 1970, before work began, showing the positions of the new crossings to be built. This development of the former Head Wrightson site, Stockton's biggest investment, is across the Tees in Thornaby. The Teesside Development Corporation has reclaimed the land, renamed it Teesdale and started a £500m development programme. The 250-acre site could eventually attract 10,000 jobs.

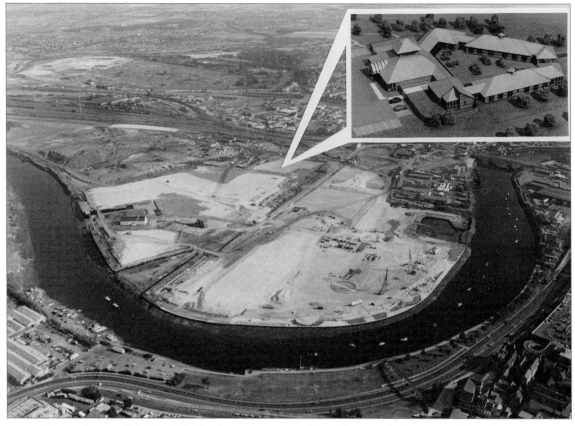

An aerial view of the Teesdale development site, Stockton, showing the location of the Alzheimers Residential Centre. The site is already home to the TFM Radio Station, Enron Power, HM Pollution Inspectorate and the £14.5m University College of Durham's Stockton Campus, which opened in 1992, the biggest higher education development of its type in Britain for twenty years. The Stockton campus, both a teaching and a residential site, has developed in response to local need. The Teesside region has one of the lowest take-up rates in higher education in the UK, 19 full-time students per 1,000 population in Teesside, compared to 42 in Tyneside and Sunderland. Durham and Teesside universities have worked together to attract more local applicants, and the Stockton operation is a key feature of that process.

In 1997–8 the Stockton campus has more than 9,000 full-time undergraduates, including 450 first years, compared with 190 in 1992 when the building opened. About half of the intake is from the region, and about a third is made up of mature students. The existing halls of residence have space for 235 students.

The college currently offers degree courses in five main areas: Biomedical Science, Education – initial teacher training, Environmental Science, European Studies (active links with 37 European universities) and Human Sciences. The excellent facilities at the Stockton site are also attracting extra conference business to the area.

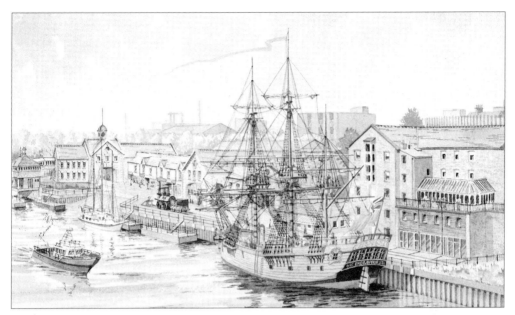

An artist's impression of Stockton's historic Castlegate Quay with a replica of *Endeavour*, river trip boats and sail training vessels.

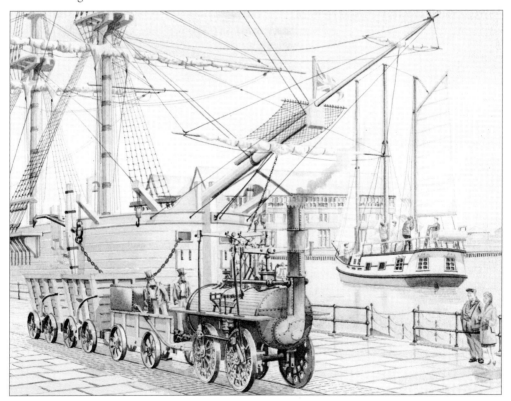

George Stephenson was the engineer of the Stockton & Darlington Railway, which was built to carry coal from coalfields in Durham to Stockton's staithes. This is an artist's impression of a replica of his *Locomotion*, sited on Castlegate Quay.

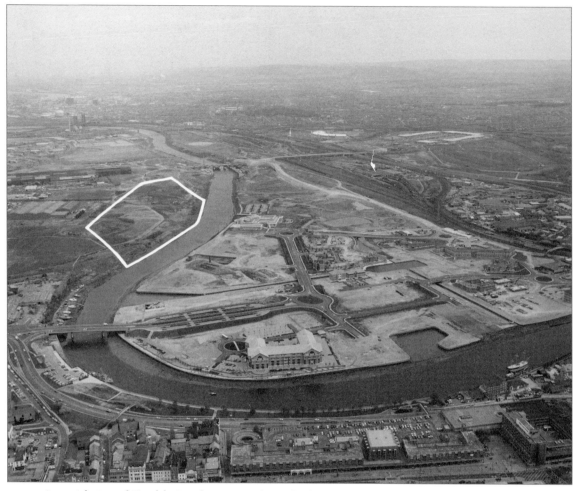

An aerial view of Teesdale Development with, in the foreground, the new bridge to the now partly developed Head Wrightson factory site and, in the middle distance, the Tees Barrage. The area outlined in white is the site for the Teesside Millennium project, which represents a £120m step into the twenty-first century. Housed in a building 600 yards wide, covering 25 acres, the project offers a first in Europe as part of England's largest single-regeneration site, both for construction and combination of use. Suspended from its steel supports is the titanium roof and surrounding dichroic glass, which provides a building of stunning visual impact and flexibility which is environmentally sensitive, energy efficient and incorporates the most advanced technology and telecommunications. Built to stand the tests of time, it is a true departure into the twenty-first century. The building provides, under one roof, entertainment, education, research and development, a seat of learning, accommodation, apartments, sports and leisure activities, and a biomedical research centre. At the same time it brings the use of the Tees into an indoor environment.

The scientific model of the Tees Barrage at the Hydraulics Research Centre, Wallingford. At a cost of £50m the Tees Barrage transformed an 11-mile stretch of the river into a lake; and allied to water quality improvements the scheme also made Teesdale a major water sports centre, including a world-class canoe slalom. Building the barrage at Blue House Point, Stockton, was one of the biggest construction projects in Britain. Begun in January 1992, construction was carried out in eight phases and entailed diversion of the Tees.

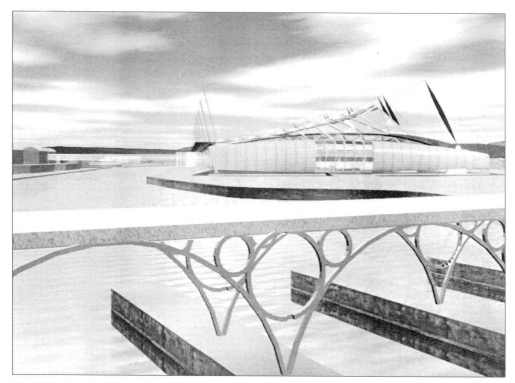

The Millennium Building as viewed from the £50m Tees Barrage.

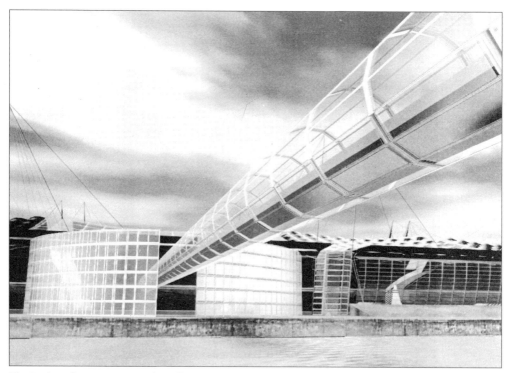

The Bridge of Learning, Teesside Millennium.

BRITAIN IN OLD PHOTOGRAPHS

SUTTON'S PHOTOGRAPHIC HISTORY OF TRANSPORT

To order any of these titles please telephone our distributor, Littlehampton Book Services on 01903 828800
For a catalogue of these and our other titles please ring Regina Schinner on 01453 731114